A Taste of Devon

Andrea LEEMAN

Photography **Stephen Morris**

G000163142

 redcliffe

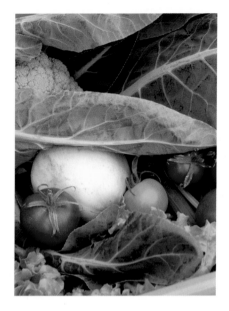

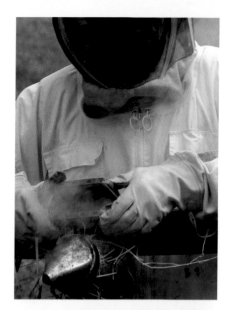

First published in 2007 by Redcliffe Press Ltd.
81g Pembroke Road, Bristol BS8 3EA
T: 0117 973 7207
E: info@redcliffepress.co.uk
www.redcliffepress.co.uk

© Andrea Leeman (text)
© Stephen Morris (photographs and map)
ISBN 978-1-904537-49-6

British Library Cataloguing-in-Publication Data
A catalogue record for this book is available from
the British Library

Design: Stephen Morris: smc@freeuk.com
Printed by CPI Bath Press, Bath

Contents

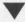

Dedicated to the
memory of my father.

Introduction

A *Taste of Devon* is a brief portfolio of some of the fine food and drink produced within this beautiful county, and touches on the lives of those involved. At the outset of the book, only its title was set in stone – the rest an empty pad and a tape recorder for the days when the West Country rain fell in bucketfuls. Suddenly Devon was not just the north and south coast of childhood memory: those 'are-we-nearly-there' coastlines now sandwiched an extensive hinterland. The winding lanes with high banks of wild flowers, running through farmyards, steeply wooded valleys and to uplands, often in the view of Exmoor or Dartmoor, came to represent its important farming heartland. All this in sharp contrast to the north coast, wind-lashed in part by the Atlantic – and the more fertile south coast with South Hams and the Dartmouth and Salcombe estuaries bordering Cornwall, and with Beer and the Jurassic coast to the East.

The variable landscape, with its temperate climate and its coasts, permits Devon to be the land of the individual producer or grower. It's hard to think of another county with such diversity, both in farming and fishing. Brixham may be the county's major fish market, but individual fishermen such as Mark Cawsey at Clovelly, the Newton family at Beer and David Kerley in the Fish Shed in Topsham, successfully tough out the competition. I learned from Maura Bailie-Bellew, snail farmer, that snails become sexually rampant during thunderstorms – and I learned how to avoid the lunging kicks of an ostrich from their breeder, Mike Godfrey. Ostrich meat

incidentally, is wondrously low in cholesterol. Hemp seed oil, grown and produced by Henry Braham and Glynis Murray in North Devon, is full of the much vaunted omega 3, 6 and 9 oils – use it as you would an olive oil. They may have future competition in the kitchen from Mark Diacono who, with global warming in mind, has just planted Devon's first olive and almond grove.

This book would be the duller without Stephen Morris's keenly observed photographs bringing sparkle to the stories. Recipes are not necessarily traditional, instead following the trail of top-class ingredients; the freshest of fish, superb lamb, beef and pork and excellent vegetables. Scones had to be included in the recipes, if only as an excuse to argue which goes first – Riverford Dairies' prize-winning clotted cream, then jam – or jam followed by clotted cream? Devonians all tell a different story. Devon does not rely only on its Farmers' Markets; there are other regular markets in addition and many good outlets for local food.

The enterprise and dedication from all those involved in the county's food business is breathtaking. Finally, I repeat the heartfelt apology, also used in *A Taste of Somerset*. It is to those who are not in the book and who deserve equal recognition, but I hope there will be an opportunity to make amends.

Andy Leeman
Bristol, February 2007

ROD and BEN

Bickham Farm · Kenn · Exeter · Devon · EX6 7XL · Tel: 01392 833833
E: RodandBen@rodandbens.com · www.rodandbens.com

The ubiquitous Rodney Hall and Ben Moseley met at Seale-Hayne Agricultural College over ten years ago before they went their separate ways – Ben to work in agricultural development in Indonesia, and Rodney, in a business removed from agriculture. Throughout my travels in Devon their names popped up constantly; then came the day when real live Rod was at his stand at the Exeter Food Show, ladling out the soups for which they have also become renowned. The tenancy for their premises, Bickham Farm, came up in 1998 and the two reunited – Rodney realising a childhood ambition to become a farmer and Ben to develop a viable organic system incorporating a vegetable-box scheme as well as supplying vegetables to Darts Farm, amongst other outlets. Rich red Devon soil runs throughout their 106 acres of land where they run a traditional mixed farm with animals, vegetables and arable crops. Vegetable boxes are seasonal, delivered within a fifteen-mile radius of Exeter to various pick-up points and you can ask for some of their own organic eggs and farm honey to be included too. They are members of DOGS, Devon Organic Growers, and although there is no shop on the premises, they host several events on the farm including farm walks.

Picnic Tomatoes

At the end of July when tomatoes become plentiful, roast for a short time
to concentrate the flavour and spoon into a screw-top jar with olive oil,
fresh basil and a little salt and pepper. A loaf of bread, a hunk of cheese
and the tomatoes-in-oil make rich picnic pickings. These are not like sun-
dried tomatoes, so use within a few days.

> 250g (9 oz) cherry or small tomatoes
> Fresh basil
> Olive oil
> Sea salt and pepper

Preheat the oven to 150°C (300°F) gas mark 2
Halve the tomatoes and spread on a baking tray. Sprinkle with a table-
spoonful of oil, a few torn basil leaves and a good pinch of salt and pep-
per. Bake for 1 hour and remove from the oven.

As soon as they are cool, spoon into a jar and barely cover with oil.
Delicious with salads, cold meats and cheeses. Use within a few days.

PHIL THOMAS and HELEN CASE

Linscombe Farm · Newbuildings · Crediton · Devon · EX17 4PS
Tel: 01363 84291 · E: info@linscombe.co.uk · www.linscombe.co.uk

Linscombe Farm's byword is Local Food for Local People.
In 2006 it won the Soil Association Box Scheme of the Year
award. Phil Thomas and Helen Case came to their mid-
Devon farm in 1996 with degrees in horticulture and an MSc
in sustainable agriculture, and plans to supply vegetable
boxes – initially a hundred or so a week. Soon it was apparent
that to make their lives viable, the numbers had to be
increased, particularly after the arrival of one son, swiftly
followed by twin boys. The farm now supports eleven workers,
including Phil and Helen. The team is led by Lucy Unwin who
is an experienced farm worker committed to organics, and
Jan Bradford, whose role extends to marketing the vegetable
boxes and generally upping the farm's profile.

The farm is a serene thirty acres of cultivated land, sur-
rounded by its ancient hedgerows and woodland. Standing
amongst long rows of brassicas, there is also a notable absence
of the pests that normally wreak havoc in a vegetable patch.
'The key,' says Jan Bradford, 'has been building up fertile,
healthy soil with the help of homemade compost, getting
young plants to kick off with a good start, to grow away from
any weeds. The odd plant at the end of a row may be attacked,
but the majority are unharmed.'

Linscombe prides itself on marketing only home-grown
produce; perforce vegetable boxes must be standard rather
than choice – whatever is ripe and ready to pick that week.
Lest a customer should find the selection monotonous, and to
cover for any crop failure, they grow three hundred varieties

of vegetables, including ten sorts of cabbages and thirty varieties of potatoes. Despite such munificent variety, the hungry gap is still a problem, occurring at the end of the winter and before the summer vegetables kick in usually around May-time: it's an ongoing challenge to Phil and Helen who are trying to shorten the seasonal dearth of produce with increased use of polytunnels and improved storage facilities.

Part of the marketing skill with the boxes is to make them visually attractive, not so difficult when the content seems to exude good health. The packing shed is new and filled with the intoxicating smell of freshly gathered vegetables. Deliveries are basically within a twelve-mile radius to save on road miles and avoid treading on competitors' toes. Crop planning, timing and quantities would appear enough of a challenge, but a very important part of Helen Case's work involves heritage seeds, varieties of vegetables that are not widely available, traditional strains with good flavours and naturally resistant to disease but which have been dropped from the catalogues. Almost all the produce grown at Linscombe Farm is raised from seed.

It may seem that Linscombe Farm's energy is focussed on their present target of three hundred vegetable boxes a week, but they also have well-stocked stalls in Crediton and Exmouth markets every month, and weekly in Exeter market.

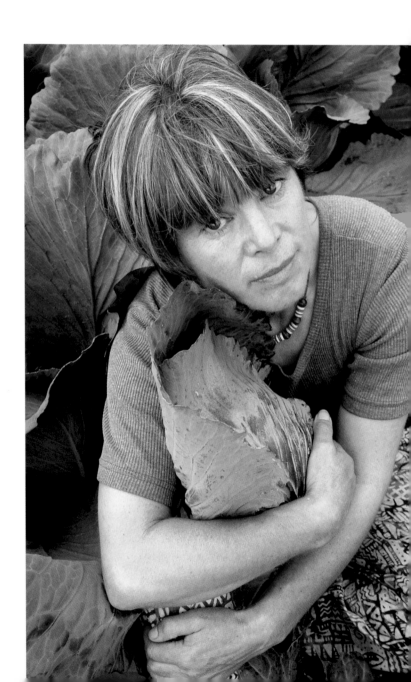

Serves 10 as a starter

It's much easier than it looks – and feeds lots of people. Best made the day before it's needed.

100g (3½ oz) asparagus

100g (3½ oz) French beans

100g (3½ oz) baby carrots

3 tbsp water

1 sachet Supercook Gelatine (or sufficient gelatine to set 1 pint liquid)

600ml (1pt) single cream

75g (2¾ oz) finely grated Quickes Farmhouse Cheddar

1 tbsp chopped tarragon

2 tsp lemon juice

Salt and pepper

Set in a 2pt loaf tin

1 Trim the asparagus and beans and scrape the carrots: steam the vegetables until tender.
 Put 3 tbsp water into a small bowl and sprinkle the gelatine over the top.

2 Heat the cream to simmering point in a saucepan, stir in the cheese and tarragon and remove from
 the heat. Add the gelatine and continue to stir until it's dissolved. Finally add the lemon juice and a
 little salt and pepper.

3 Rinse the loaf tin in cold water. Pour in some of the cream mixture followed by a layer of vegetables
 – continue until all the vegetables and cream are incorporated.
 As soon as the mixture is cold, refrigerate for 4-5 hours until properly set.

4 Dip the tin momentarily in hot water, run a knife around the edges and turn out on to a plate.
 Serve with a mixed green leaf salad and hot toast.

Serves 4

There is a delicious moment in spring when English asparagus coincides with the first of the broad beans – and when vegetarians and non-vegetarians might settle for the same dish with equal enthusiasm. If it's too early for beans, then peas are good too.

450g (1 lb) asparagus

1 tbsp olive oil

1 medium onion, peeled and finely chopped

300g (10 fl oz) risotto rice

700ml (1$^{1}/_{4}$ pints) vegetable or chicken stock

1 glass white wine

150g (5$^{1}/_{2}$ oz) fresh broad beans

1 tbsp freshly chopped mint

100g (3$^{1}/_{2}$ oz) hard farmhouse cheddar such as Quickes

Salt and pepper

1 Wash and trim the woody ends from the asparagus, cut into 2.5cm (1") lengths. Heat the olive oil and gently cook the onion until soft.

2 Add the rice and stir with the onion until it's coated with oil. Slowly add the stock, stirring continuously. When the rice has absorbed all the stock, pour in the white wine and add the asparagus pieces and beans and continue to cook and stir until the asparagus is tender. Add the fresh mint and most of the cheese. Taste the risotto and add salt and pepper accordingly.

3 Sprinkle over the last of the cheese, add a few mint leaves and a grind of black pepper. Serve immediately.

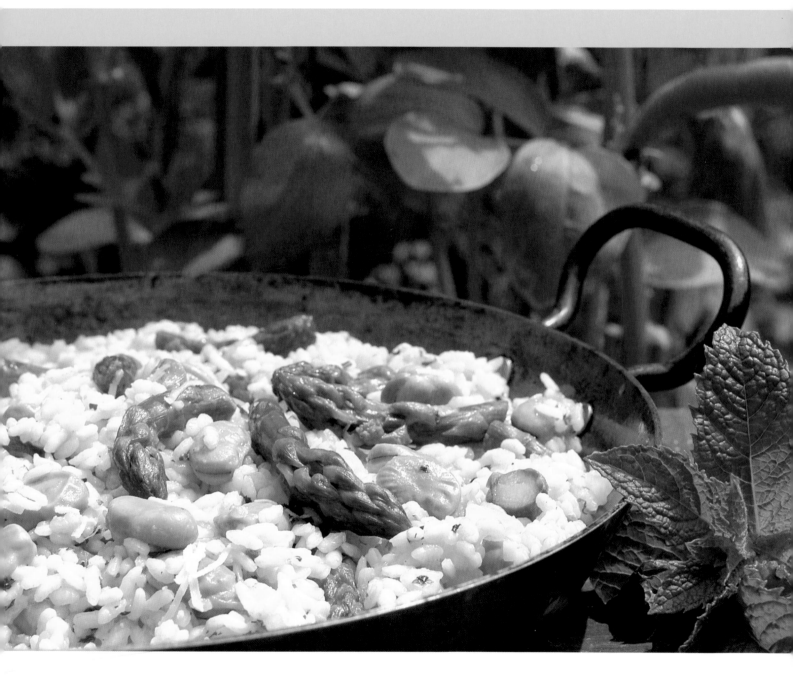

WEST COUNTRY OSTRICH

Mike Godfrey · Crinacott Farm · Pyworthy · Holsworthy · Devon · EX22 6LJ · Tel: 01409 253401
E: sales@westcountryostrich.co.uk · www.westcountryostrich.co.uk · www.mnsostriches.co.uk

You may not catch an ostrich on the wing, but lanky legs propel the birds at up to 50mph, and can sustain a steady 35mph for lengthy distances. If the plume feathers are up, it's not the beaks to watch for, rather the lunging kicks from their powerful two-toed feet, designed to do unspeakable things to the foe. Deep booming, canting – a rocking with one wing, then the other – and strutting steps are all part of the warning ritual.

Mike Godfrey made their acquaintance in 2002. He was a chartered electrical engineer in London, but after a coronary bypass, decided to change his life, and with his son Nigel and daughter Rachel, to relocate the family business to the West Country. Crinacott had been converted to farm ostriches in 1996, but suffered a series of set-backs, culminating in the foot and mouth epidemic in 2001, preventing movement and effective sale of the birds – without compensation. At this low ebb, Mike, Nigel and their families came to buy the farm, primarily for its empty buildings, but became interested in the potential of ostriches and their healthy meat – and hence found themselves a second career.

The enterprise needed modernising, a new hatchery, an in-house slaughter unit and a meat cutting and packing plant. It took a year to build and get the licence to operate, so the real ostrich business began in September 2003, by which time the birds were costing £6,000 a month in high-protein food.

The ostriches feed on pellets that contain high-protein Lucerne, mixed with vitamins and minerals and a small amount of cereal, and in ten to twelve months birds can grow to 100kg and with 35-40 kilos of meat. Their skins can make soft but durable leather, providing it isn't damaged through scrapping, something which occurs more as they mature sexually. Ostrich eggs are the biggest of all, but the smallest in proportion to the birds; each egg is equivalent to a couple of dozen hens' eggs – an omelette for a giant. There's always a market for the regal plume feathers and some of the eggs are blown and used to make decorative items like clocks and musical boxes.

Hatching is timed for the summer months so birds are raised more economically in natural heat – it takes about forty-two days and all the ostriches live out of doors, although there's always housing available should they want shelter. One of Mike Godfrey's problems is the low-flying military aircraft; the noise spooks the birds and they hurtle themselves at their fencing, sometimes pole-vaulting themselves over into brambles and bushes and causing distressing injury. Prolonged rain is another anxiety as the plumage is not naturally oily; wet can penetrate their feathers, causing hypothermia and occasionally death if they are not brought in. However, ostriches are generally strong and healthy, and once they reach adulthood, seldom need antibiotic or other medical intervention.

The meat is just what the doctor ordered: low in fat, low in cholesterol, in fact the fillet and rump steaks are virtually fat-free. Burgers, sausages, pies and all butchery is done at

Crinacott Farm – and they recommend use of a George Foreman-style grill pan rather than fierce direct heat because of the low fat content. The meat is delicious, a little like beef with a lightly gamey touch, and adaptable to all sorts of dishes. It's possible to buy from the farm door, but please ring beforehand. Deliveries are nationwide, but you can also catch up with Mike Godfrey and all the family at Plymouth, Okehampton, Exeter, Ivybridge, Kingsbridge, Totnes, Exmouth and Tavistock Farmers' Markets. For more information about Farmers' Markets, see page 101.

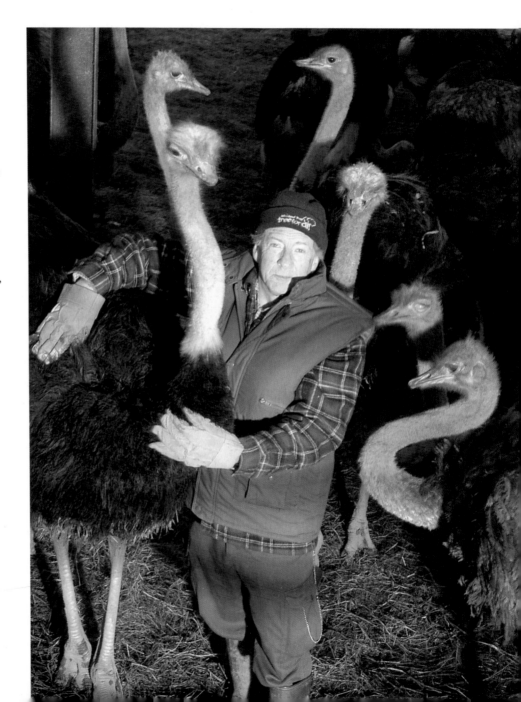

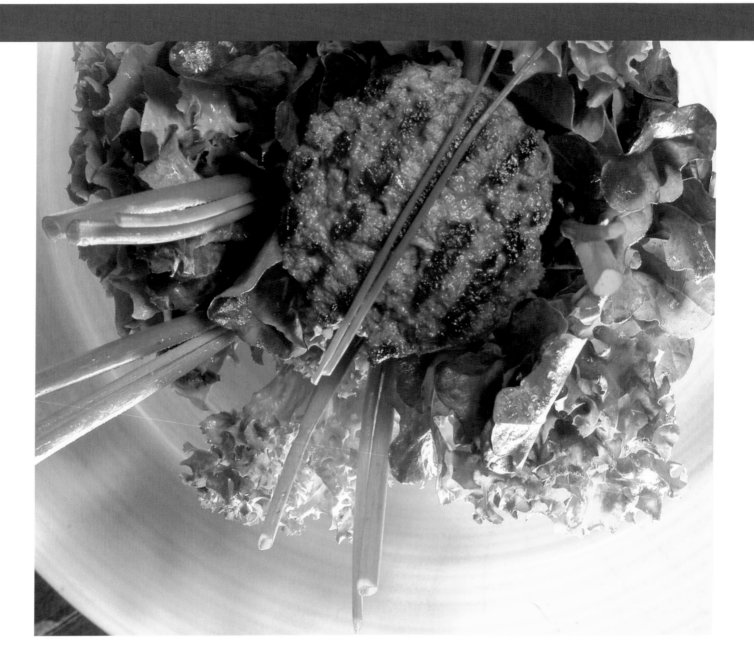

Ostrich Burgers with Pickled Cucumber, Tomato and Mint Salad

Serves 4

There are few meats leaner than ostrich and venison. The tip when cooking ostrich is to brush oil lightly over the outside of the meat before adding it to the hot grill pan. This is healthy, fresh-flavoured food and the accompanying minted salad with pickled cucumber and tomato is delicious with either ostrich burgers or ostrich steak. The pickled cucumber can be made the day before.

 1 cucumber
 1 tbsp chopped mint
 4 tomatoes
 Salt and black pepper

Marinade for the pickled cucumber
 2 tsp caster sugar
 2 tbsp boiling water
 2 tbsp cider vinegar
 1 tsp dried dill

1 Cut the cucumber in half lengthways, scoop out the seeds and dice the flesh. Spread out on a plate, sprinkle generously with fine salt and leave for 30-40 minutes. Meanwhile, make the cucumber marinade by mixing the first two ingredients, then adding the vinegar and dill.

2 Tip the cucumber into a sieve and rinse away the salt under the cold tap – add to the marinade and refrigerate overnight.

3 Halve the tomatoes, squeeze out the seeds and dice the remaining flesh into small pieces. Drain the cucumber from its marinade, mix together with the tomato and fresh mint. Add a little sea salt and black pepper and serve immediately.

RICHARD and LIZZIE VINES

Hillhead Farm · Chagford · Devon · TQ13 8DY
Tel: 01647 433433

Richard and Lizzie Vines live on the part of Dartmoor where trees give way to big skies, and cattle grids create the boundaries for roaming livestock grazing the open moorland. Richard was a cavalryman until his late twenties: as we watched eight of his Welsh Black cows with their new-borns knee-deep in rich meadow, and discussed rounding up his cattle from the moor, he wondered if perhaps he'd missed a vocation as a cowboy. Post-army, he ran pubs for Watneys and Grand Metropolitan, before the move to Devon in 1979. His personal life went awry, and for four rather desultory years he lived in an old cabin, gradually rekindling working life with twenty acres of land, a Land Rover, a Yorkshire terrier and twenty-five cows.

The word from Hillhead Farm is that traditional farming is responsible for the fine quality of their beef. The herd was founded with South Devons and Welsh Blacks – South Devons are big animals with ancestral roots in the Channel Islands. 'They yield Desperate Dan-size steaks and are locally known as Devon balers because of their food consumption. Crossing them with a north Devon bull has produced animals of a better shape and size.' Richard's cattle graze on unimproved pasture on the moors, cliffs and meadows in the West Country. Recent changes in farming, such as the single payment to some farmers to keep land both grazed and maintained in a low-key way, have enabled Richard to enlarge his own herd by taking keep on unimproved pasture in Wiltshire and Hampshire.

Richard Vines's view is that unimproved pastureland with its deep-rooted grasses, weeds, herbs and shrubs allows animals to forage naturally for trace elements and minerals: he sees improved pasture with rye grass and clover as the light-weight stuff, 'the side salad of things as far as his animals are concerned'. The spring calvers and older bullocks are out-wintered, using hedgerows for shelter: the Welsh Blacks, whose resilience is sufficient to out-winter on the moors, need leering – to be taught their boundaries, initially by being fed within those boundaries and then by following other members of the herd. Weaned calves and autumn calvers are housed before returning to pastureland in April. To keep their growth pattern as constant as possible in this period, Richard feeds his own hay and silage ad lib; if growth slows too much in store, a sudden spurt in spring causes excess development of connective tissue and ligament, all of which has then to be butchered out.

In line with government edict, animals are slaughtered at thirty months, taken to the abattoir in Ottery St Mary where things are as stress-free as possible. The meat is hung for a minimum of three weeks and it's between the second and third week that an interaction between bones and meat causes a loss of the water from the carcase, tenderising and concentrating flavour.

Life for Richard and Lizzie Vines is always on the hoof. They sell in Crediton, Wells and Taunton Farmers' Markets, in South Zeals Stores and the local Spar shop in

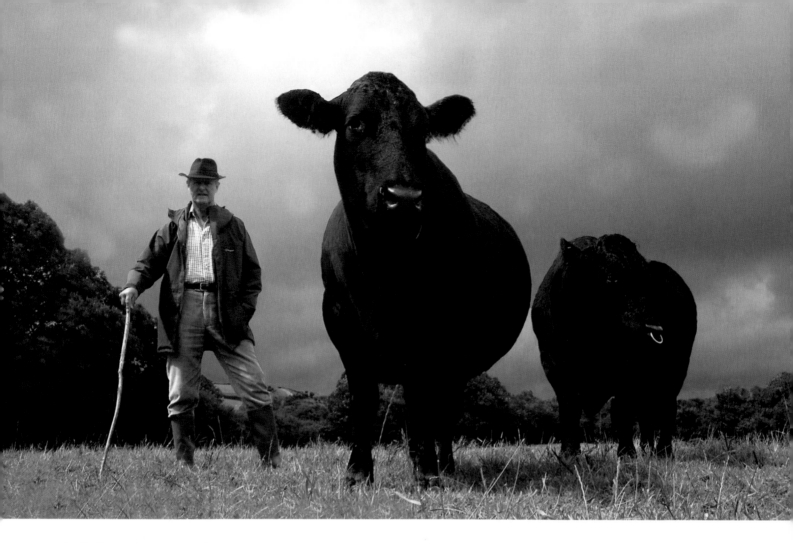

Chagford. London is a weekly trip in Lizzie's now some-
what reconfigured white van, to the Borough Market and
Broadway Market in Hackney. You can buy by mail order or
telephone and order whatever cuts of meat take your fancy
and arrange to collect it locally.

Steak and Ale Pie

Serves 6

Traditional, irresistible on a winter's day, and most of the preparation can be done in advance.

2 tbsp plain flour, seasoned with salt and pepper

1 kg (2lb 4oz) stewing steak, diced

2 tbsp sunflower oil

2 onions, peeled and sliced

1 tsp English mustard

300ml (½ pt) Branscombe Ale

400ml (14fl oz) beef stock

1 tbsp tomato purée

Salt and pepper

2 sprigs thyme

Bay leaf

Pastry

300g (10½oz) plain flour

50g (1¾oz) lard

100g (3½oz) butter

Salt and pepper

Iced water

Preheat the oven to 180°C (350°F) gas mark 4

1 Put the seasoned flour into a polythene bag, add the steak and shake it all about until the meat is coated. Heat 1 tbsp oil in a frying pan and brown the meat, put into a casserole with a lid.

2 Heat the rest of the oil in the pan and gently fry the onions until soft and beginning to brown. Add the mustard, ale, stock, tomato purée and a little salt and pepper to the onions. Stir until beginning to simmer, pour into the casserole with the meat, thyme and bay leaf and fold the ingredients together. Cover and cook in the centre of the oven for 2 hours.

3 To make the pastry, add a pinch of salt and pepper to the flour. Either use a mixer or rub the fats into the flour, adding a little iced water until the dough is cohesive. Rest the pastry in the fridge for 30 minutes to stop it shrinking.

4 Turn the oven up to 200°C (400°F) gas mark 6. Put a pie vent in centre of the dish to let the steam escape. Spoon in the cooked steak and cover with the pastry; use any odd scraps of pastry to decorate the top. Glaze the crust with a little milk. Cook for 30-40 minutes in the top oven until golden.

SOUTH HAM LAMB

Roger and Dodie Huxter · Welland Down Farm · Sandford · Crediton · Devon · EX17 4EN
Tel: 01363 775928 · E: dodie@huxter.fsworld.co.uk

They call themselves sheepoholics and rear their sheep and cattle in the heart of mid-Devon, from where on a clear day Dartmoor traces the line between land and sky. Roger and Dodie Huxter took self-imposed exile from Langport over the border in Somerset about seven years ago. Roger was a soil and water engineer and Dodie a teacher, although even at this juncture they were keeping sheep and cattle to sell as breeding stock.

We first met in the Farmers' Market in Exeter and in the snatched conversation between serving customers, Dodie said she thought their company should be called something along the lines of Inside and Out, 'after all not only are our sheep sold for meat but we market the fleeces too.' Sometimes in their entirety, sometimes spun, sometimes as garments. It used to be that the fleeces paid for the shearing alone, but the wool market is buoyant and they are becoming a bigger part of the business rather than just a bi-product.

The farm is 124 acres with mixed soil and vegetation, some of it with shale and pockets of clay under the topsoil. Initially there were hiccups with the move, first the foot and mouth outbreak and then a plummeting of numbers of lambs born – traced finally to a shortage of cobalt and selenium in the ground. Today the Huxters have 350 sheep, Poll Dorsets, Suffolk, Wensleydale, Shetland and Lleyn. The Poll Dorsets are renowned for their quality fleeces and are docile and good mothers, obligingly breeding at any time of the year so there is 'lamb for all seasons'. The Shetlands and Wensleydales

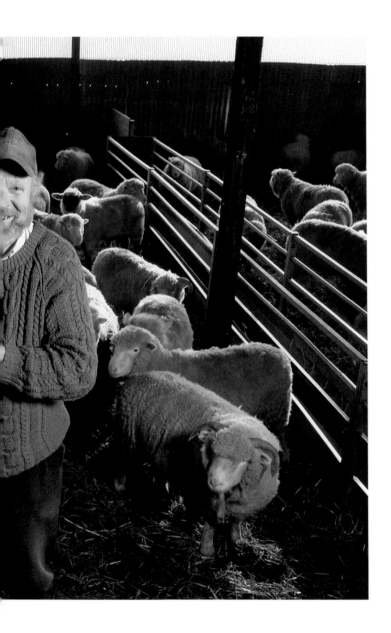

provide flavoursome lean meat and luxurious fleeces.

The Huxters also rear Red Ruby Devon cattle – smaller than their South Devon counterparts and beautiful animals with enviable auburn coats as curly and dense as astrakhan. The leader of the herd, a female called Fee, moved with them from Somerset and still provides them with a calf a year. The females from the herd go for breeding, but while on the farm the calves remain with the mothers for nine months; males are sold for meat unless there is a particularly charming bull. The well-marbled beef is hung for three to four weeks and sold at Cullompton Farmers' Market.

Welland Down Farm makes a conscious effort to grow fodder for its animals. Whole-grain barley goes to the sheep, it's rolled for the cattle and the straw goes for bedding. They also make hay and silage and grow kale, turnips, swedes, peas and beans. When the grass is thin in winter, there is leafy forage for the sheep to pick through. Visiting in chilly January and viewing the sea of amiable bovine and ovine faces warm in their barn, I felt like saying, hey – move over.

Welland Down Farm markets its produce as South Ham Lamb and it sells at Crediton, Cullompton, Tiverton and Exeter Farmers' Markets, also in some of the Somerset markets (see page 101). Freezer packs are available and you can buy from the farm direct but it's essential to telephone prior to visiting. Crediton is the nearest town and Kennerleigh the nearest village.

Braised Lamb with Barley, Sage and Cider

Serves 4

Leg or shoulder-of-lamb are both suitable for this dish; if using shoulder, allow a further 45 minutes' cooking time.

> 2 shallots
> 2 tbsp sunflower oil
> 750g (1lb 10oz) of diced leg of lamb (about $1/2$ a leg)
> 1 sprig sage
> 1 bay leaf
> 250mls (9fl oz) good cider
> $1/2$ tsp smoked red paprika
> Sea salt and black pepper
> 2 tbsp pearl barley
> Chopped parsley to serve

Preheat the oven to 180°C (350°F) gas mark 4

1 Peel and slice the shallots. Heat the oil in the bottom of a pan and soften the shallots for 2-3 minutes.

2 Add the lamb, turn and seal in the oil and transfer the meat to a casserole.

3 Add the sage, bay leaf, cider and paprika. Sprinkle with a good pinch of sea salt and a grind of black pepper. Cover and cook for 45 minutes.

4 Stir in the pearl barley and continue to cook for a further 30 minutes or until the pearl barley is tender. Check the seasoning, sprinkle with chopped parsley and serve.

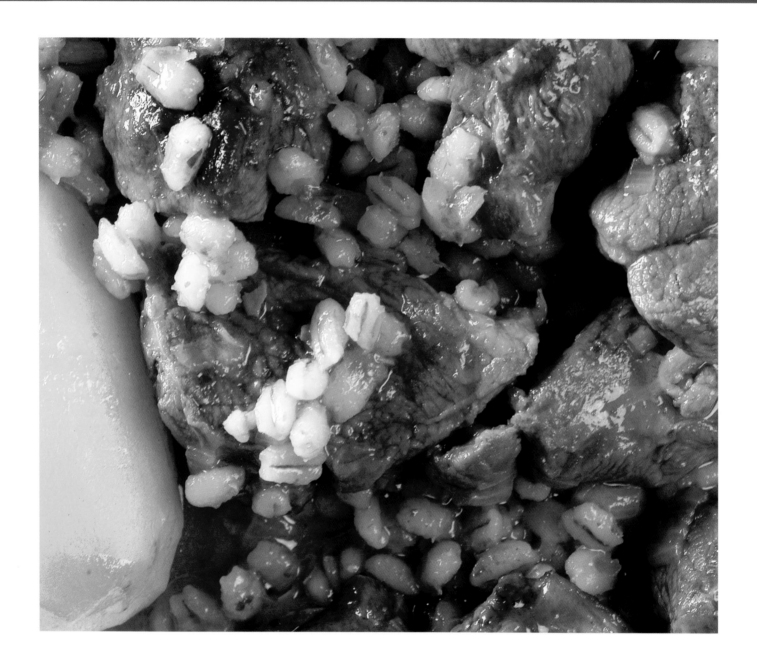

RICHARD and LINDA HARVEY

Frost Farm · Hennock · Devon · TQ13 9PP · Tel: 01626 833266

Frost Farm was once on the main road from Exeter to Bovey Tracey, but the route has returned to a winding Devon lane with banks of stitchwort, ragged robin and bird song. Richard Harvey was born on the farm and took over the running of it at nineteen when his father died. On the day of my visit, he was nursing a broken nose, the result of a run-in with a cow that had recently given birth and was proving the point that cows can be as volatile as bulls – indeed she had been poised to have a second go had he not been fleet of foot. The farm was once managed on conventional lines, 140 acres of land with a dozen cows, two to three sows, sheep and some arable farming.

Today the acreage has doubled and Richard and his son Jeffrey run the farm together. They have travelled full-circle, going over to cereals at one stage, but have returned to mixed farming, shouldering the cost of becoming organic fifteen years ago. The Organic Farmers and Growers Association are keen that as many farms as possible in Devon should take on organic status. But, as Richard points out, production and sales need to work hand-in-hand as however fine the produce, the marketing can present a problem, particularly if there is a surfeit of similar organic food in one region.

Frost Farm's sheep are Suffolk crosses, good grazers and total some three hundred breeding ewes. The lamb, together with some of their Hereford beef, is marketed through Riverford Organics. Richard Harvey grows old varieties of cereals and uses the long wheat straw for thatching his farmhouse. Triticale, a cross between wheat and rye, is grown for winter animal feed; it's sufficiently sturdy to lift itself clear of the weeds, even on less fertile soil.

The farm's return to pig breeding is a recent one. Two or three years ago a neighbour asked Richard to rear some pigs and he began with weaners, but 'rapidly lost control of the situation'. He says, with feeling, that pigs are very destructive, eating and digging up everything in their path: they finally drove him to the decision that he must either make full provision for the enterprise, or give up the idea. He now has a purpose-built, state-of-the-art sty, spacious and clean, and the pigs go out into paddocks in the summer. He keeps a basic stock of six sows and a boar, Gloucester Old Spots and some Saddleback X's – the sows have litters of nine to ten piglets twice a year. Apart from making a few sausages, all the meat is sold to Simon Handslip of The Devon Meat Company (see page 34) – neat and successful marketing.

The problem with pigs, according to Richard, is that they can become bored and subsequently destructive. He was interested recently at an Oxford University Farm open day to find pigs in an open yard being fed cereal-based silage; they seemed well contented and there was a marked absence of the usual piggy smells. He now feeds his pigs with home-grown clover-based silage with dramatic results – happy pigs and a more fragrant farm.

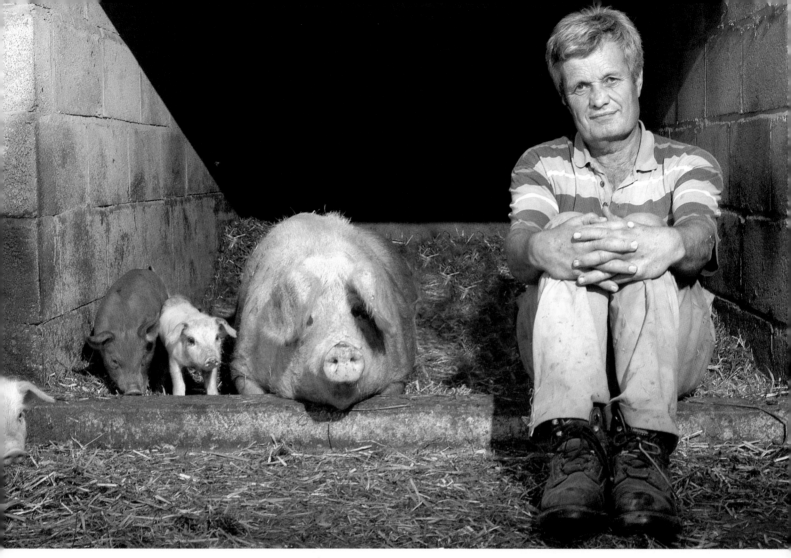

Frost Farm lamb and beef is marketed through the Riverford Farm Shop at Staverton, near Totnes TQ9 6AF, tel: 01803 762523; Riverford Goes to Town, 38 High Street, Totnes, TQ9 5RY, tel: 01803 863959. The pork is available from The Devon Meat Company, tel: 01548 821034.

If you would like to meet the animals and enjoy the surrounding countryside, Frost Farm has cottages to let, organised by Linda Harvey, tel: 01626 833266.

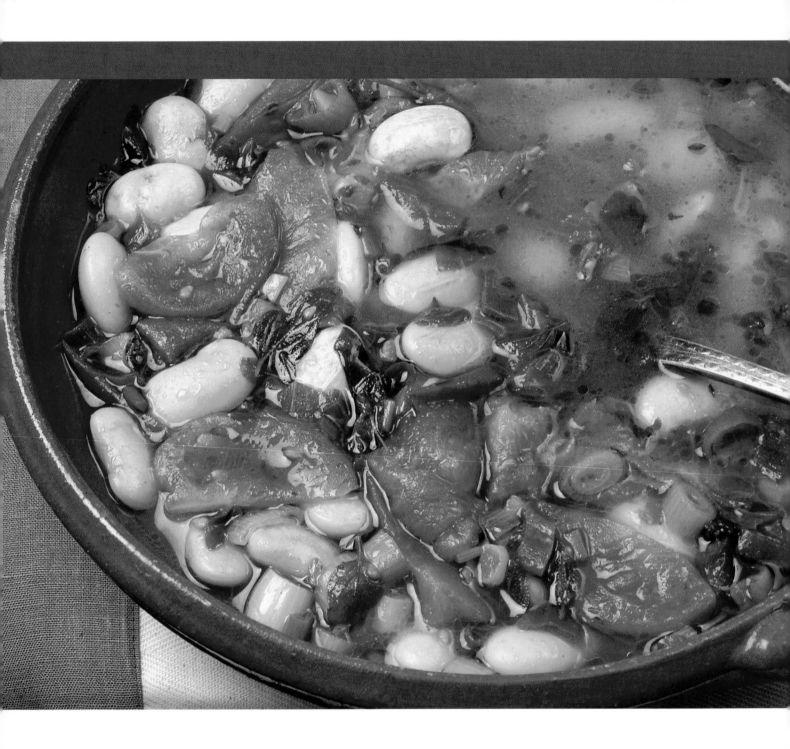

Serves 4

Richard Harvey enjoys his pork, simply roasted and with crackling.
To make it especially crunchy, make sure the skin is scored, and just
before putting the meat into a very hot oven for its first twenty minutes,
pour a kettleful of boiling water over the top and wipe the skin dry
immediately.

The sweet meat and crackling produced from a slowly roasted shoulder
cut is mouth-watering, my favourite – and a dish of butterbeans, jazzed
up with oregano and a touch of chilli, is delicious as an accompaniment.

200g (7oz) dried butterbeans, soaked overnight

2 tbsp olive oil

1 bunch spring onions, chopped and including most of the greenery

4 fresh tomatoes, roughly chopped

2 tbsp chopped oregano or flat-leaf parsley

1/2 a fresh chopped chilli

200ml (1/3 pt) chicken stock

Salt and pepper

Preheat the oven to 180°C (350°F) gas mark 4

1 Heat the oil in an ovenproof casserole with a lid. Add the spring onions and
 tomatoes to soften, add the rest of the ingredients, stir and cook with the lid
 on for 45-60 minutes.

2 Before serving, check the beans are tender and adjust the seasoning
 if necessary.

THE DEVON MEAT COMPANY

Simon and Carole Handslip · Lupridge · Diptford · Totnes · Devon · TQ9 7NW
Tel: 01548 821034 · www.thedevonmeatcompany.com

Dapper grey-and-white speckled Guinea fowl saunter on the edge of the track to the farmhouse, rooting for delicacies. Five years ago Simon and Carole Handslip retired from London; Simon had been involved with marketing – and Carole has been a food writer, food stylist and author of a number of cookery books. They now live on a smallholding in hilly farming country between Totnes and Plymouth. The Devon Meat Company evolved from combined efforts between Simon Handslip and Andrew Hendy, traditional sheep breeder on the neighbouring farm, to market Andrew's lamb. Since then they have formed a consortium with Richard Barker raising pedigree Aberdeen Angus beef and rare breed sheep at the historic Fowlescombe Farm,* and have been joined more recently by Richard Harvey who produces the consortium's pork from his free-range Gloucester Old Spots and Saddle Backs at Frost Farm.

The Devon Meat Company's aim is to reflect the farmers' care and commitment to their animals during the breeding by providing top-class butchery and effective marketing. The consortium has recently built a new cold store and butchery and now employs a full time butcher, Wayne Grice, a skilled young man who enthuses not only about his work, but is interested in the welfare of the animals and in talking to the farmers about their stock. All cuts of meat are available from prime lines such as chateaubriand, the crème-de-la-crème of fillet steak, to whole legs of lamb and shoulder of pork that 'when cooked with fennel and garlic in a slow oven, falls from the bone in a tasty heap', to meat for pot roasts, braising and pies. There are cured meats too, gammon, bacon, sausages – and as Simon is a licensed game dealer, venison, pheasant, partridge and rabbit when in season.

The home-built smokery is a triumph in its simplicity; green oak chippings are fired up in a brazier and the cold smoke conducted to the smoking chamber – a stainless steel milk container in a previous life. The company is entitled to sell meat direct to the customer rather than via a butcher's shop: Simon claims modestly they run a waiting list for their Aberdeen Angus fillet, with wing rib and fore rib on the bone as hot contenders. The Handslips decided to cash in on the flavoursome cheaper cuts by launching a range of delicatessen products. Carole's professional background is essential for the masterminding of current productions from the recently converted Fowlescombe kitchen, and in stepping into new epicurean terrain with mouth-watering results. They make bresaola, salt beef, handsome pastrami and pâté: homemade salami was unveiled the day of my visit, likewise chorizo sausages. A recipe for potted ham was at the development stage, but required further fine-tuning, according to its creator.

The Devon Meat Company will deliver locally, and by mail order all over the country with an overnight delivery – and equally, should you fancy a few friends in for a hog roast, the telephone number is 01548 821034.

* Fowlescombe Farm is on a medieval farm site in South Hams, two miles south of Dartmoor.

Pork and Chestnut Pie with Cranberries

Serves 10

Carole Handslip of The Devon Meat Company has written many successful cookery books and now develops recipes for a delicatessen range of products for the business. This handsome pie won a gold medal at Taste of the West Food Awards, summer 2006. (There is no seasoning in the list of ingredients because sausage meat is normally well seasoned)

750g (1lb 10oz) sausage meat

100g (3^1/$_2$oz) cooked chestnuts, chopped

150g (5^1/$_5$oz) smoked bacon, chopped

1 small onion, chopped

50g (1^3/$_4$oz) dried cranberries

1 tbsp parsley, chopped

500g (1lb 2oz) shortcrust pastry

1 egg yolk lightly whisked with 3 tbsp milk for glazing

Preheat the oven to 200°C (400°F) gas mark 6

1 Put all the ingredients except the pastry into a bowl and mix well.

2 Cut off 2/$_3$ of the pastry and use to line a 20cm/8" loose-bottomed sandwich tin.

3 Using the rolling pin, lift the pastry over the tin and ease it in, leaving an overlap around the sides. Press the filling into the pie case and dampen the top edge of the pastry with a little cold water.

4 Roll out the remaining pastry, lay it over the pie and press the edges together firmly. Trim with a sharp knife and press a pattern around the edge with thumb and forefinger to seal and decorate. Roll out the trimmings and use to cut diamond shapes for decoration.

5 Make a small hole in the centre of the pie, dampen the pastry around it with a little cold water and arrange the diamonds around the hole.

PORK RILLETTES

Serves 6

The first-class pork produced in Devon is perfect for making rillettes. Cook the pork belly very slowly in a low oven with a little cider and thyme. When the meat is so tender that it almost literally melts, it's shredded, seasoned and packed into a storage jar with a little fat on top to seal it until required. This is great lunchtime food, served with rough crusty bread and a glass of the self same cider.

> 1 kg (2lb 4oz) pork belly
> 4 tbsp dry cider
> 1 sprig thyme
> Sea salt and pepper

Preheat the oven to 150°C (300°F) gas mark 2

1 Cut the pork into 5cm (2") chunks and put into a lidded casserole with the cider, thyme and a little salt. Cook in the oven for 4 hours until the meat almost melts.

2 Keep the juices but lift the meat with a slatted spoon on to a large plate. Cut away and discard the skin and fat; pull the grains apart with two forks. Reunite the meat with the juices and add more seasoning to taste. Pack into suitable storage jars. When cool, top with a little melted fat or lard and store in the fridge until required.

SUZANNE'S VINEGARS

36 East Way · Ivybridge · Devon · PL21 9GE
Tel: 08456 120377 · E: info@suzannesvinegars.co.uk · www.suzannesvinegars.co.uk

The drive and skill to extract keen fruit flavours must be in the genes; Suzanne Lewis's great-grandparents were the inventors of Maynard's Wine Gums. Suzanne trained as a home economist, then became a restaurateur and over the years experimented with the family raspberry vinegar recipe, giving it increased fruit content and viscosity, and followed its success with six other fruit recipes. Now, she is the Mark Spitz of vinegar-makers. In 2005 her vinegar essences won five gold medals and one silver and, in 2006, at the Taste of the West Awards her Strawberry, Balsamic and Mint Dressing won gold, her Blackberry, Cardamom and Chilli Dressing won gold, Lime, Mustard and Ginger took silver and Raspberry, Balsamic and Rosemary, bronze.

Add a splash of raspberry vinegar to smoked chicken and avocado salad – or the gooseberry and elderflower to grilled mackerel or salmon – while the blackcurrant makes a distinguished addition to a red-meat marinade.

GOOD OIL

Henry Braham and Glynis Murray · Collabear Farm · North Devon · EX31 3JZ
Tel: 01271 858377 · E: info@goodwebsite.co.uk · www.goodwebsite.co.uk

It was the will of the Elizabethan parliament that every farmer should grow an acre of hemp, essentially to supply the navy with the vital fibre for sail and rope – the word 'canvas' is derived from cannabis, explains Henry Braham. Henry and his wife Glynis Murray are in the throes of planting two thousand acres of cannabis in North Devon, not for an hallucinogenic jamboree as the seed is different, but as an essential kitchen ingredient. Hemp oil, once the preserve of health food shops and sold in small bottles for medicinal purposes, is now sold as a delicious khaki-green oil made from hemp seeds with high levels of essential fatty acids, aka the much-vaunted omega oils 3, 6 and 9. The oil, incidentally, bears not a smidgen of marijuana; it's used by lots of athletes and is rigorously tested by the appropriate authorities each year. Hemp appears to be the near-dream crop to grow.

Far from a distraction, Henry Braham and Glynis Murray's double life as cinematographer and film producer by week and hemp farmers by weekend seems, if anything, to redouble their focus, impressive knowledge and enthusiasm for their crop. They are the biggest hemp farmers in the UK and the only people producing it primarily for culinary purposes. This project, they say, could not have been done in isolation: trial and error have been a par for the course and they have achieved success with the unstinting help and cooperation of their farming neighbours. Now they want us to take a leap of faith, to change our eating habits and use it as one might use olive or sunflower oil. I am a perfect convert and even drizzle the oil on my toast at breakfast time – adding the more conventional marmalade, of course.

When Henry and Glynis took on Collabear Farm, the land had been used for dairy farming and much of the grassland was exhausted. They took a look at what might work, but it was Henry's stepfather who spotted an article in *Farmers' Weekly*. They began to grow hemp, initially for fibre. After shallow ploughing in the spring, the seed is planted when the ground warms up and once established, the plants can shoot to ten or twelve feet. In farming terms, it's probably one of the most environmentally exciting plants of its kind, requiring half the nitrogen intake of wheat, for example, and needing no pesticides or herbicides. The leaf canopy smothers out the weeds beneath. It matures in early September when the leaves drop, returning phosphate and potash to the soil. The top seed is harvested, leaving the straw on the ground where useful bacteria get to the fibre to break down the lignum so the fibre separates from the woody core. The same acreage can be used repeatedly.

Every bit of the hemp plant is used. Whilst East Anglia supplies Devon farmers with straw for livestock, so the lorries return laden with hemp straw that is made into loft insulation material, the lining for BMW door panels because of the strength and biodegradability – and now into building blocks. Adnams, the brewers and wine merchants of Southwold in Suffolk are in the process of using the blocks to build a distribution centre. Henry pondered what could be done

with the residual dust from these procedures – it's now used as material for breeding worms, the type that enhance compost.

The hemp oil is produced at the farm all year around. In the calm of a vast shed, oil drips slowly from two cold-press machines, simultaneously turning the husks into cattle food. Previously hemp seed oil has come from the States where sales are big and flavours often pungent and bitter with chlorophyll. Glynis and Henry have worked long and hard to perfect the flavour; Waitrose offered expert advice and took the initiative with the presentation and marketing, selling it as Good Oil in 500ml bottles and displaying it with olive and other oils – rather than in the health food section. At present it's available from Harvey Nichols, Fresh & Wild, Selfridges, Holland & Barrett, larger Tesco and Sainsburys, and some branches of Waitrose. The project is exciting, the oil is delicious, Jamie Oliver approves – and it gives a glint in the eye and a spring to the step.

Vinaigrette

Hemp seed oil, marketed as Good Oil, makes excellent vinaigrette. As with all oils, it has a limited life, so make enough vinaigrette for a few days at a time. Mix together:

 4 tbsp Good Oil
 1 tbsp white wine vinegar
 1 level tsp caster sugar
 1 level tsp sea salt
 Chopped herbs and garlic – optional

Glynis Murray's son Ben, contributes to the family business at Collabear Farm by developing recipes using the hemp seed oil.

I liked his idea of simple bruchette, using good bread and local ingredients for the toppings.

Ingredients for the photograph were a large country-style loaf, sliced and toasted under a grill. The bread was then rubbed with garlic and sprinkled with the Good Oil.

From left to right in the picture:

Quickes Farmhouse cheddar, under the grill for a minute – and served with Otter Vale apricot chutney.

Blissful Buffalo mozzarella, tomatoes, fresh basil, sea salt and black pepper.

Pancetta (Italian-style thin streaky bacon), Devon pork, prepared by the Dartmouth Smokehouse, and served with local quails' eggs.

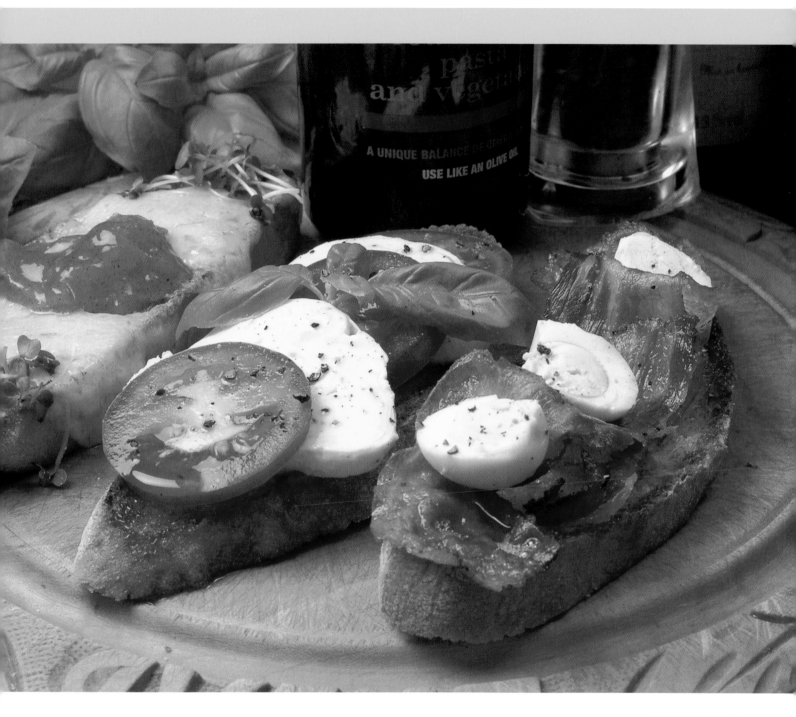

MARK DIACONO

Otter Farm · near Honiton · Devon · Tel: 01404 548927 · Mob: 07870 771535
E: mark@otterfarm.co.uk · www.otterfarm.co.uk

Environmental surveyor, yes: horticulturalist and farmer, no – at least not yet, he says. Mark Diacono is learning on the hoof and his venture is in its infancy. 'It's the perfect excuse to ask lots of questions with impunity – no-one expects me to know the answers at present.' Until a year or so ago, environmental surveying took Mark all over the country, then he bought the Devon house with 17 acres of smallholding. In the course of his work, the gradual influence of climate change impinged on his mind and led to some inspirational ideas for his land. Like Archimedes, he says his best ideas came while he was in the bath.

Mark Diacono divided his enterprise in two. The first half would involve climate change trees and plants – small groves of olives, almonds, pecans, persimmons and apricots. Part two would be forgotten fruits, medlars for jelly, mulberries, quince for cheeses, walnut trees – and some sweet chestnut dotted around the perimeters. On one of the glorious summer days of 2006 we walked around the land, admiring the healthy saplings and plants, brushing the leaves of the young walnuts that smelled – surprisingly – of lemon sherbet, noting the olives already showing a miniscule crop with promise of what's to come in five years or so. A field of globe artichokes bearing their first fruit were going to lose their heads this year to help the plant build strength for future growth.

The olive trees are from Tuscany, seasoned by three winters of frost, rain and snow in their native Italy and grown by Emilio Ciacci of Tuscan Trees whose partner Esther Yorke lives in Sherborne, Dorset. Olives are their business and Mark's enterprise will act as their shop window for those who may wish to follow suit with a similar project. Mark describes his venture as meeting climate change half way. The local soil is mixed alluvial, silt and remaindered river gravels after the River Otter changed its course: he's had to dig deep to plant the trees and access good drainage. The grove is under-sown with self-seeding red clover that doubles as a winter mulch and nitrogen fixer for the young trees. A sea of purple phaecelia grows beneath persimmons, pecans and mulberries, performing a similar task.

We headed to the banks of the Otter river that borders one side of his land and watched a kingfisher streak along the water; shortly after it gave its sharp whistle and returned at a more leisurely pace. Nearby a fallen tree trunk is to be impregnated with mushroom spore. Whilst the outcome of this venture remains in the lap of the weather, all the other ingredients are in place for exotic results in the heart of the Devon countryside and I can't wait to revisit in a year or so.

SOUTH DEVON CHILLI FARM

Jason Nickels and Steve Waters · South Devon Chilli Farm · Wigford Cross · Loddiswell · Devon · TQ7 4DX
Tel: 01548 550782 · E: enquiries@southdevonchillifarm.co.uk · www.southdevonchillifarm.co.uk

South Devon's easy-going weather may lend itself to chilli growing, but it required the imagination of Jason Nickels and Steve Waters to convert what had been a hobby practised in their greenhouses at home, into an enterprise with flair that found itself short-listed in the national finals of the HSBC Start-Up Stars Award. In the summer of 2005, their third summer in business, they moved from Kingsbridge to Loddiswell to a ten-acre site which not only offered more land for the chilli growing, but also enough space to create an apple orchard and to plant crab apple, elderberry, hawthorn and blackberries. At present their apple jelly is made with fruit bought via Orchard Link, an organization that puts orchards with excess apples in touch with people that need them.

The production of the fresh chillies is their primary target, followed in the winter months by the bottling and preserving fruits and berries, incorporating everything from Thai-style chilli sauce and chilli jam to chilli chocolate. All is home-made; Steve makes anything that's preserved in a jar, while Jason deals with all the bottled sauces. The chilli crop is treated as an annual one, although a few hardy varieties from the Andes will over-winter. Preparation begins in February and March when the seedlings are brought on in heated greenhouses until mid-April when plants are transferred to the polytunnels, by which time the tunnels will sustain enough natural heat to see the crops through the summer and autumn. Harvesting this colourful crop begins in mid-June and runs until early December; with the exception of the Show Tunnel, the tunnels are then rotavated and prepared for the following year using soil from their fields, mixed with homemade compost.

Much of the crop is sold fresh in the markets, but others are mashed and frozen or dried and smoked for sauces and preserves. The dried chillies take on a different culinary persona and some varieties are grown specifically for this purpose, such as the long twisty Pasilla, used in Mexican sauces. Jason's favourites are the oak-smoked Jalapeno – they go well with meat dishes, or added to soured cream to make a dip. Generally the most popular are Habaneros, alias Scotch Bonnets, hottest in the range – because of their very distinctive, fruity flavour. Some caution is needed when handling chillies; eyes are particularly sensitive.

Despite the fact that mouse-deterrent powders contain chilli powder, Devon mice are the biggest pest in the poly-tunnels, gnawing their way into the tops of the peppers and sitting inside eating the seeds. However, ladybirds do a good job on unwelcome insects.

The South Devon Chilli Farm – open daily from spring to autumn; otherwise telephone to check opening times – is well worth a visit. Jason and Steve sell at Exeter, Kingsbridge and Plymouth Farmers' Markets; also in farm shops and delicatessens in Devon and into Somerset. The nearest local farm shop to Loddiswell is Sorley Tunnel, a converted railway tunnel on the A381 from Loddiswell to Totnes.

Serves 4

This recipe came from a friend who thinks it may have originated from Australian chef, Bill Granger. It is delicious, simple summer eating and the better because the chillies are Devon-grown and the chicken, free range and also local.

Chicken in honey, soy and sherry

 125mls (4fl oz) soy sauce

 2 tbsp sunflower oil

 2 tbsp runny honey

 2 tbsp dry sherry

 1 garlic clove, peeled and crushed

 1 tbsp peeled and grated fresh ginger

 1 red chilli, de-seeded and finely chopped

 8 free-range chicken thighs or a whole chicken, skinned and boned and chopped in pieces

 Cucumber, coriander and lime wedges to serve

1 With the exception of the chicken, stir all the ingredients together in a small bowl.

2 Rub the marinade into the chicken with your hands and put the chicken plus the remaining marinade in a suitable dish to steep for an hour or so.

Preheat the oven to 180°C (350°F) gas mark 4

3 Place the chicken, skin-side-up on a shallow roasting tray and bake for 30 minutes.

Sweet chilli sauce

 2 red chillies, de-seeded and finely chopped

 250mls (9fl oz) rice vinegar

 2 tsp salt

 1 garlic clove, peeled and finely chopped

 175g (6oz) caster sugar

1 Combine the ingredients in a small saucepan and stir over a low heat until the sugar dissolves.

2 Bring to the boil and simmer for 5 minutes until the mixture thickens to a slightly syrupy consistency.

3 Remove from the heat and allow it to cool.
Serve with chunks of lightly salted cucumber, coriander, lime wedges and steamed rice and the bowl of chilli sauce on the side.

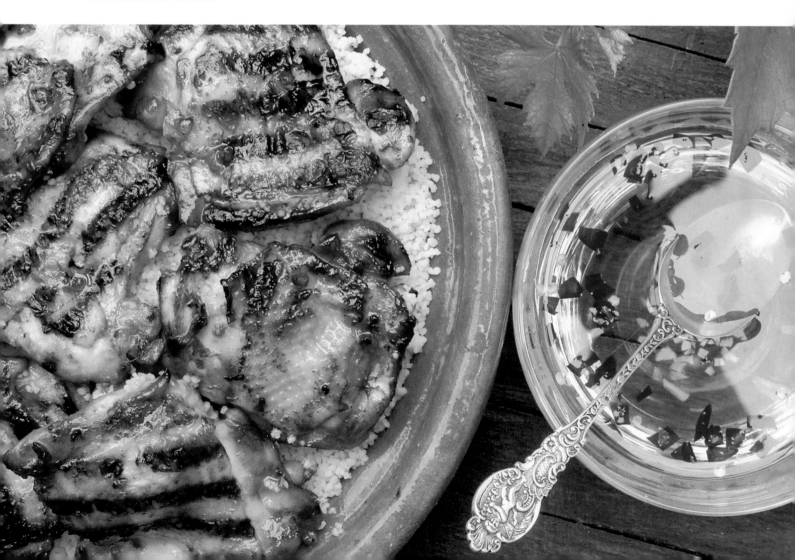

SOUTH WEST SNAILS

Maura and Dave Bailie-Bellew · North Nethercleave Farm · Umberleigh · Devon · EX37 9AD
Tel: 01769 540103 · E: swsnails@aol.com · www.south-west-snails.co.uk

Maura and Dave Bailie-Bellew were in the police force in Buckinghamshire when Dave suffered severe head and other injuries resulting from a fall. He was invalided out of the force in need of rest, care and a new lifestyle; their first child was four months old. The family found a house plus outbuildings in Devon, all in need of refurbishment and so with Maura's limited farm experience as a child in New Zealand, they took on a few rare-breed cows, sheep and pigs. They have, as Maura says, had to rebuild their lives very slowly. The snail project evolved from an article in a magazine about an existing Devon snail farm, no longer operating, but it was clear that proper specialist knowledge was needed for such an enterprise to be a success; so Dave enrolled on a course. Watching these creatures chomp indomitably through one's garden, it's an eye-opener to find out just how vulnerable they are, and how much effort goes into successful breeding.

The Bailie-Bellew household pumps out energy, enterprise and a certain organized chaos. There are now four small daughters. Even the Dandy Dimont dog was busy with a new litter. There are several projects in hand, animals to be fed – North Nethercleave Farm has enlarged their pig stock to a hundred strong and they hand-make quantities of sausages each week. The snails are Helix aspersa maxima as opposed to Helix aspersa that are the smaller garden variety. Maura points out 'if you're a snail farmer, you've made yourself indispensable, you can get someone else to feed the pigs but snails are another matter. They have to be kept at the right

temperature and with low UV, too much and they become sterile, too little and they don't assimilate calcium and have brittle shells. They don't like smoke, perfume or vibrations and water must be pure.'

Despite not liking vibrations, snails do like thunder storms; given the amount of water inside their shells, they sense the pressure change and, as Dave says, the snail tunnel soon becomes a glorious lovefest. Snails are hermaphrodite but pass sperm to one another with calcium-based darts. In the wild they take two years to mature, but the bred variety are ready to reproduce in six months and need to lay at the right time to prevent becoming egg-bound. Each lays a total of about three hundred pearl barley-sized eggs, up to a hundred at a time. Snail caviar used to be seen in the smart eating-houses in London and Paris in the eighties but it's a fashion that has passed. Once we ate as many snails as the rest of Europe after being introduced to them by our Roman invaders. Some of the Nethercleave snails are sold live to restaurants, others carefully prepared before they hit Maura's cooking pot, laced with wine and the appropriate herbs and vegetables. She puts them into presentation shells and adds the garlic butter, after which they are blast frozen.

As their collection of Large Black, Berkshire and Tamworth pigs grew larger, Maura decided to make sausages herself, and by using rice flour rather than wheat, is able to market them with the added attraction of being gluten-free, suitable for those with Coeliac disease. All the ingredients for their eleven

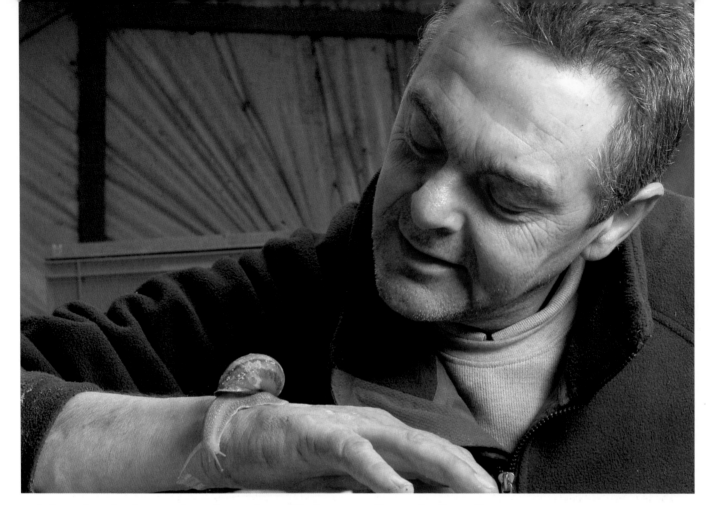

varieties such as the ginger, spring onion, apples, and herb are hand-hopped, made on Fridays and taken by Dave to the local market in South Molton every Saturday. The labels read 'Tailor Made'; they will make whatever flavour of sausage you want, but the order must be a minimum of five kilos.

You can buy from the farm on Mondays and Fridays, and courses on snail farming are also available.

Devon Snails on Toast

An original recipe from Maura Bailie-Bellew:

Wrap each snail with a little of its garlic butter and half a teaspoonful of blue cheese in Parma ham or similar. Place on toast with the crusts off and put under the grill for a couple of minutes.

Serve hot with a crisp dry white wine and a big napkin for buttery fingers.

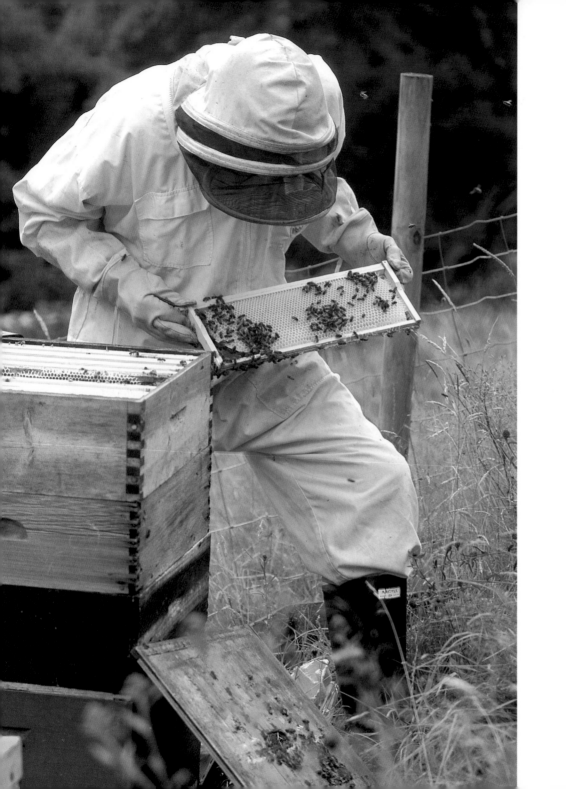

BLACKALLER HONEY

Peter Hunt and Hazel Phillips · Rosemary Cottage · The Village · North Bovey · Devon TQ13 3RA
Tel: 01647 440322 · E: peter@blackaller.fsbusiness.co.uk · www.blackaller.fsbusiness.co.uk

Yes, there's honey still for tea. Pots of it, thanks to native Devon bees and apiarist Peter Hunt, himself a Cornishman. His passion for beekeeping was sparked off as a lad of thirteen but his interests then turned to wildlife with an eye to working at Slimbridge. Next came a £10 one-way ticket to Australia and penultimately he trained as an hotelier. Peter and his partner Hazel ran the Blackaller Hotel in North Bovey for fourteen years where Hazel was the cook. She still keeps her hand in, producing delicious honeyed flapjacks and honeyed muesli, amongst other things. Peter's urge to work on something environmentally friendly persisted and when the hotel was sold a couple of years ago, beekeeping took over and he now has eighty stocks or hives of bees.

The busiest time is May and June, both for beekeeper and bees. If you see a beekeeper on the run or staring up a tree, it's because a Queen and about half the hive, up to thirty thousand bees, have swarmed, abandoning it to younger stock. Before swarming, she will lay special Queen's cells for a new generation of Queens. At around fifteen days when the tips of the cells are ripe and appear as though surrounded by a black ring, the eggs hatch. In Machiavellian style, the first Queen to hatch bumps off the remaining Queens. The sole duty of the Drones is to fly into special drone zones in wait for virgin Queens – and, not allowed back into the hive in the autumn by the workers, they die when food is limited and the first frosts come.

The Queen is fed on Royal Jelly, its constituents still defying precise analysis; it's a substance produced by bees, looking and tasting rather like yoghurt and harvested only by the Chinese. The Queen will live for two to three years, her death determined by the workers when the number of eggs she produces is reduced.

Peter Hunt's bees take nectar mostly from dandelion, buttercups, sycamore, lime, bramble, clover and willow herb. In August he scoops up the caviar of the bee-keeping business, heather honey from bell and ling heather on Dartmoor. On a good day, the bees stop flying at about 7.00pm and will work all night in the hive, evaporating moisture from the nectar with their wings. The humming and smell of the nectar permeate the night air; it's not surprising the life of a worker bee can be as short as three weeks.

The honey is collected in two flows, May and July. It's the pollen grain that makes the difference to crystallization but if it goes too hard, the honey can be 'creamed' to break down the crystals. The bees cluster together in cold winter weather, but damp is a hazard, as are mice in the hives, and of course varroa, which is a mite.

Life may sound busy enough, but Peter also owns twenty-four Jacob sheep and spins their wool while Hazel organises a network of people to make it up into hats, scarves and jumpers. Blackaller honey is on sale at Exeter, Crediton, Cullompton, Tavistock and Okehampton Farmers' Markets, also in Val's Stores in Moretonhampstead, the vegetable shop in Chagford or from the door.

Serves 10

An exotic honey, chopped-nut and cinnamon-spiced pudding with crisp layers of buttery pastry – Greek in origin, but eminently suited to Devon ingredients, right down to the cream to pour over it.

> 85g each (3oz) pistachio, hazelnut and almonds
> 1 tbsp Demerara sugar
> 1 tsp ground cinnamon
> 100g (3¹/₂oz) unsalted butter
> Filo pastry (Cypressa is good and widely available)

For the syrup

> 4 tbsp runny honey
> Juice and finely grated zest of a small orange
> 2 tbsp water

Preheat the oven to 200°C (400°F) gas mark 6

1 Chop the nuts, either by hand or in a mixer, stir in the Demerara sugar and cinnamon.

2 Melt the butter. Line a baking tray approximately 30cm x 25cm (12" x 10") with baking parchment and paint with a little butter. Put in three layers of filo, painting the top of each layer with butter. Don't worry about the overlaps.

3 Sprinkle with half the nut mixture, then repeat the 3 layers of buttery filo: add the last layer of nuts and a final 3 layers of pastry. Use a sharp knife to mark the top into diamond-shaped portions. Trim the overlaps with scissors.

4 Mix the honey, orange, orange zest and water in a saucepan and bring to simmering point. Bake the pudding for 20 minutes – put a couple of unbuttered sheets of pastry over the top to prevent the pastry from burning – return to the oven for another 10 minutes. Remove from the oven and pour the boiling honey syrup over the top – it should sizzle as the honey works its way through the layers. Best eaten the same day, or slightly warmed first. Sprinkle a little icing sugar over the top just before serving.

Garlandhayes Venison

Steve Casely · Garlandhayes Farm · Westcott · Cullompton · Devon · EX15 1SB
Tel: 01392 881262 · Mob: 07919 246655

An imposing pair of antlers fit for a baronial hall is the first hint that deer are just over the hedge. On closer inspection, there are two herds, pale caramel-coloured fallow deer, looking spectral against their sturdy counterparts – the big red deer of Scottish lineage.

They belong to Steve Casely. His grandparents owned Garlandhayes farm in the early twenties, later to be run by Steve's father. When his father died, in 1979, Steve was twenty-one and he and his sister took over. Work on the farm carried on much as before, focussing on dairy, beef, corn, potatoes and some contract work until 1986 when Steve felt the cereal industry was going down. He happened to see a magazine brought out by MAFF, containing an article about deer farming by Dr John Henshaw. Cereal crops were reduced and cattle sold to free up the land for the new venture. It was selling the venison that proved a sticking point; marketing the meat around pubs and hotels was arduous and time-consuming.

Steve contacted Dr Henshaw who helped to form a local group; they struck lucky with a leading supermarket chain that had previously had problems with quality and continuity. Cheques arrived promptly and everything in the garden was rosy until the supermarket ran a promotion for customers, reducing the price in the shops and asking the suppliers to reduce charges accordingly. The group called their bluff – and lost the contract, notwithstanding the fact they were left with unsold carcasses.

The next move was to cut out middlemen and return to selling direct, this time through Farmers' Markets. Venison is at its prime between fifteen and twenty-seven months. Now his meat goes to Wallace's of Hemyock (see page 59) to be dressed out; the meat is stamped after inspection and returned to Steve to be hung for ten days after which it's butchered and trimmed into cuts such as fillets, saddle on the bone, medallions and haunch steaks. The trimmings are transformed to burgers and sausages with red wine and apple. A Zimbabwean friend makes Biltong, a dried meat and a South African speciality; Steve himself makes Boerwos, a South African spicy sausage.

Now the herd is nearing three hundred strong, the majority of them red deer. The antlers are cut for the rutting season to protect both the hinds – and Steve. They sit in the back of a shed and now-and-again a Chinese man turns up to collect them for medical use. In the winter, hinds and calves come in and are fed home-grown hay and silage. Basically deer are healthy animals. Steve has lost only two animals in calf, and that was in the early days when he overfed during the winter and the deer were too big to give birth with ease.

He says he begins to watch for his new calves in the week of the Devon County Show – in other words, May.

Venison makes for healthy eating, low in cholesterol, high in protein and very lean; cooking times for many cuts are minimal. You can buy pies, pâtés and pasties, sausages and burgers and many cuts of meat from the Farmers' Markets in Buckfastleigh, Crediton, Cullompton, Exeter, Exmouth, Honiton, Newton Abbot, Ottery St Mary and Tiverton. It's also possible to buy from the door, but please ring in advance to make sure someone's there to help you.

Serves 6

The recipe is based on one of Graeme Wallace's favourites, and is unfailingly good.

2 medium onions, peeled and sliced

2 tbsp olive oil

2 cloves garlic

150g (5 1/2 oz) chopped smoked bacon pieces

1 kg (2lbs 4oz) casseroling venison, diced

600ml (1 pint) ruby port

1 bay leaf

6 juniper berries, crushed

4 tbsp redcurrant jelly

Salt and pepper

Preheat the oven to 150°C (300°F) gas mark 2

1 Soften the onions and garlic in half the oil, add the bacon pieces and fry until the fat
begins to run. Seal the venison in batches in the rest of the oil. Add 425ml (3/4 pint)
of port, the bay leaf and juniper and some salt and pepper and cook for 2 hours.

2 Add the remaining port and the jelly and continue to cook for a further hour.
Check the seasoning.
Serve with red cabbage or beetroot salad dressed with sea salt, walnut oil and vinegar and
lots of mashed potato to mop up the gravy.

WALLACE'S of HEMYOCK

Hill Farm · Hemyock · Devon · EX15 3UZ
Tel: 01823 680307 · E: info@welcometowallaces.co.uk · www.welcometowallaces.co.uk

After three years living and working abroad, Graeme Wallace shunned the notion of city life and moved to Hemyock in 1986 to a hundred-acre farm. Diversification was the current buzzword in farm speak and an article in *Farmers Weekly* set him on the trail of deer farming. In the autumn of 1986 he fenced some of his land and bought thirty red deer, but to sell the meat he needed to knock on the doors of local hotels and restaurants, a time-consuming business. In 1993 MAAF declared that venison must be butchered under the same conditions as other meat so he built a licensed processing unit and butchering room. Trade built up and he continued to deliver the meat himself.

The birth of the Farmers' Markets was around 1996/7. Graeme had never retailed directly to the public before, but the opportunity arose at Cullompton, after Bath, the first Farmers' Market to open in the West. He recalls the thrill of the day – he sold out by 10.00am, dashed back to the farm to restock only to sell out again and return home with a pocketful of cash. Business had taken off. Thereafter 'the Venison Man' was at every market, ultimately totalling eighteen a month.

After the success of Cullompton and the necessity to spend time away from the farm, Graeme employed a butcher and his wife. More and more people found the way to the farm and the feeling was, oh well, why don't we have a small shop? The small shop outgrew its premises to be replaced with an all-singing shop and restaurant, focussing on top quality local food and drink: the restaurant would perform as a showcase for the foods on sale.

Wallace's retains the family feel, Graeme is a hands-on man and cares deeply about all aspects of the business. In 2006 they won the title of Non-Multiple Farm Retailer of the Year in the British Food and Farming industry Awards. They have their own smokery. The butchery counter alone is worth a visit, particularly for bison and venison from their own farm and free range Saddleback cross Duroc pork from next door. If that's not tempting enough, then there's Dartmouth Smokehouse salmon, Vulscombe goats' cheese, honey from the Blackdown Hills, Sharpham brie, Andrew Gabriel's white, brown and blue hens' eggs, homemade cakes, Lyme Bay Fruit Wines, Somerset Cider Brandy, Sheppy's Cider – to name but a few. The restaurant, like the shop, is open all day and serves delicious home-cooked food. Farm shop and restaurant are on the Blackdown Hills near the Wellington Monument, on a small road that runs parallel with the M5. They are open seven days a week, Monday to Saturday 9.00am-5.00pm: Sunday 10.00am-5.00pm. Closed Christmas and Boxing days.

Serves 6

Red cabbage is a classic accompaniment to venison and other game dishes; it's one of the few vegetables that reheat well. If you like a tarter version, replace the red wine with red wine vinegar.

750g (1lb 10 oz) red cabbage, thinly sliced
1 onion, peeled and thinly sliced
1 Bramley apple, peeled, cored and sliced
Soft dark brown sugar
1 tbsp olive oil
3 tbsp red wine
Salt and pepper

Preheat oven to 190°C (375°F) gas mark 5

1 Layer the cabbage, onion and apple alternately in the pot. When completing each layer, sprinkle over 1 tsp sugar and some salt and pepper.

2 Spoon over the olive oil and wine, cover and bake in the centre of the oven for 1^1/$_4$-1^1/$_2$ hours.

TRACEY MILL and TROUT FARM

Angie and Clive Gammon · Tracey Road · Honiton · Devon · EX14 3SL
Tel: 01404 45114 · E: info@traceymill.co.uk · www.traceymill.co.uk

Comfortable in their family home in Somerset and working respectively as strategy manager for the Social Services and policeman, Angie and Clive Gammon's plans for a lifestyle change were a decade away in the grand scheme of things. Both had talked of doing something together post-retirement, but were caught unawares by empty-nest syndrome when their last child left home. Tracey Mill offered itself as an irresistible project. When the handover took place after a two-day briefing with the previous owners, things looked very daunting. A mill, a lot of trout, a river supplying a million gallons of water a day and everything to learn.

Tracey Mill was already a trout farm and has been a water mill used for milling flour for almost four hundred years. Clive Gammon is in the process of completing the restoration of the machinery with its two sets of French Burr stones, and soon the flour will again be in production. However the trout ponds were the first priority. These are natural clay, fed by the River Otter that rises in the Blackdown Hills in Somerset and continues from Honiton to meet the sea at Budleigh Salterton, near Sidmouth. Clay ponds mean the trout don't pick up the muddied flavours that can be the ruin of a good fish.

The ponds are dug around the mill leat from the River Otter, so the fish live in fresh flowing water and, by maintaining low stocking levels, remain healthy and well oxygenated. Fingerlings are bought locally for restocking, three or five thousand at a time, and take about ten months and a supplement of GM-free food to reach plate-size. The majority of the fish are Rainbows, but a few Brown trout have crept in and if stocks are sufficient, can be bought at the Mill. With the exception of one or two more northerly rivers, Rainbow trout don't normally breed in the wild in this country but the Gammons now have a few young, naturally bred Rainbows.

Angie's job extends to the kitchen. As well as fresh, whole trout, Tracey Mill produces smoked trout fillets, smoked trout pâté, trout fishcakes, fish stock, quiches and Gravadlax. It's a seven-day-a-week enterprise with the cleaning, gutting, brining, hot and cold oak smoking and packaging – and on a fine weekend, cream teas. Angie is also a licensed preacher at the local Anglican Team Ministry.

You can buy trout at the Mill, but it's worth ringing in advance as life is hectic and in addition to the food preparation and general maintenance, Tracey Mill sells at twenty Farmers' Markets a month including Ottery St Mary, Dawlish, Exmouth, Teignmouth, Cullumpton, Tiverton, Honiton and Seaton. You can also arrange mail order through their website.

I took a couple of trout home, grilled them with a little butter and sea salt and served them with toasted almonds, chopped fried parsley and lemon juice – a time-old recipe, nonetheless delicious.

Serves 4

If the trout are quite large, slash the sides in a couple of places as you would a mackerel. Rub the skins with a little oil and sea salt and barbecue, grill or wrap in tin foil and bake in a medium oven for about 20-30 minutes.

For the sauce

1 egg yolk

$1/4$ tsp English mustard

150ml ($1/4$ pt) sunflower oil

Tabasco

2 tsp lemon juice

Sea salt and pepper

1 tbsp fresh dill, finely chopped

1 tbsp fresh tarragon, finely chopped

3 tbsp water

1 Tip the egg yolk into a mixing bowl with the mustard. Whisk and gradually add half the oil until the mixture thickens as a mayonnaise. Add a couple of drops of Tabasco, the lemon juice and a good pinch of salt, whisk again, gradually adding the remainder of the oil.

2 Heat the water to simmering point in a small pan and add the chopped herbs, simmer for a further thirty seconds and remove from the heat. Allow them to cool for a minute, stir the herbs and water into the mayonnaise base. Check the seasoning.

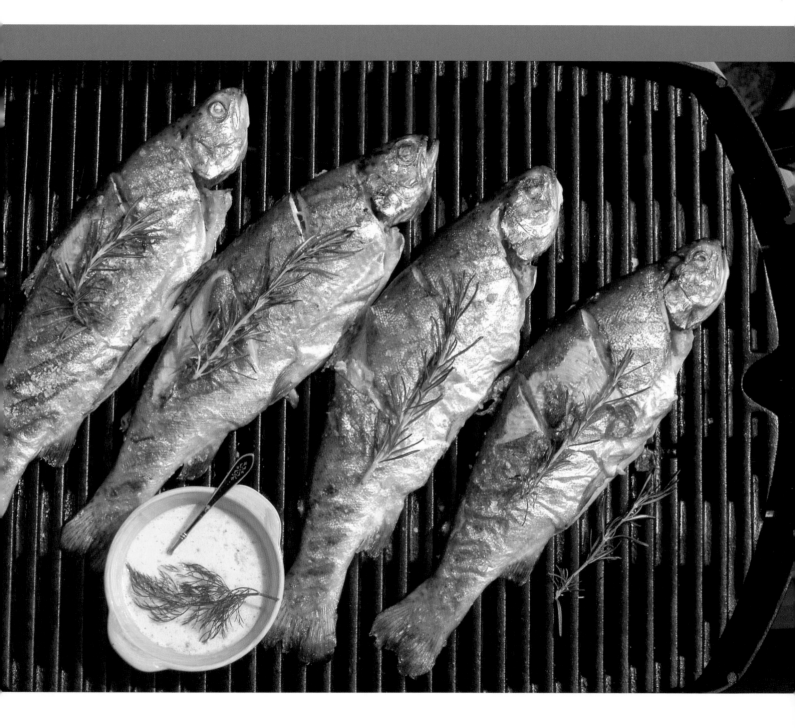

THE WET FISH SHOP, BEER

The Sea Front · Beer · Devon · EX12 3NE
Tel: 01297 20297

This is hidden treasure: Beer lies between Branscombe and Seaton in southeast Devon. As one walks towards the sea, silhouettes of small fishing boats stand proud on the foreshore of the pebbled beach, and a mile or so to the west of Beer the cliffs begin to change from the limestone of the Jurassic coast to the red sandstone of Sidmouth. In Beer there are beach cafés and stripey deckchairs, and the sea gulls and children shriek with one voice. I have bought big fresh crab here, still warm from the cooking pot and have later sat on a sunny step and cracked into the claws with a rolling pin to extract the sweet meat – saving their shells to make bisques.

Jim Newton is the fourth generation in his family to work in the shop on the slipway, together with his father Roy who has previously spent a good part of his life at sea and who was responsible for the first harvestings of scallops in the area. Crab and lobster pots are tended and the fishing now done by Roy's three brothers, David, Cyril and John – they own three of the boats on the shore. There are two son-in-laws who also work in the shop; it's a thoroughgoing family business.

I asked if there had been any extraordinary catches. 'Well, a ten-pound lobster.' Their main trade is in crab, lobster, scallops, mackerel in the summer, sea bass, skate, huss, plaice and sole. They are open all the year round from about 8.30am-4.30pm, including Sundays. Ring if you're after something special, if not, take pot luck.

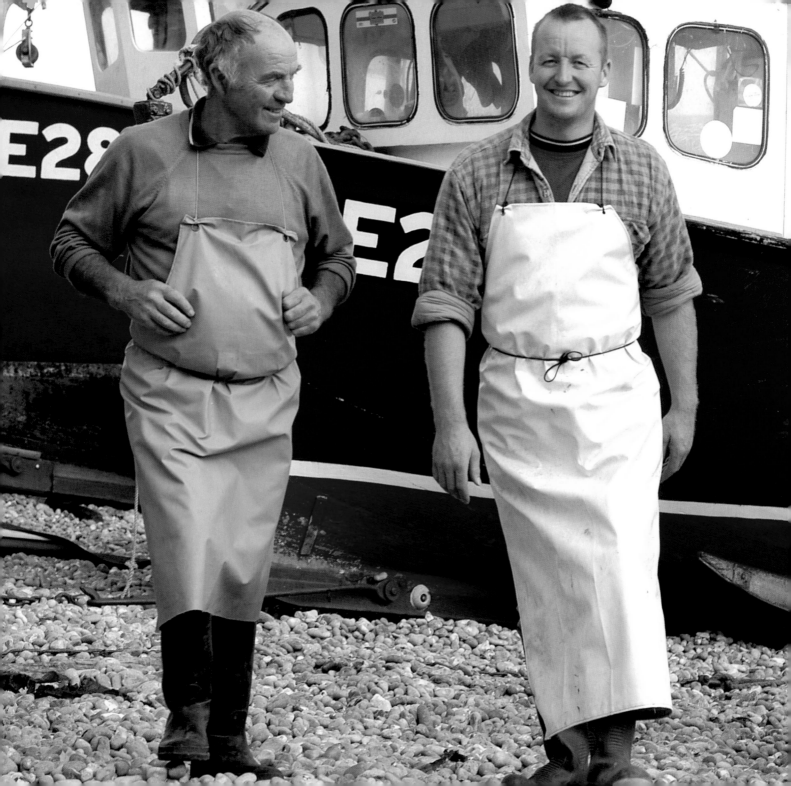

DARTMOUTH SMOKEHOUSE

Nelson Road · Dartmouth · Devon · TQ6 9LA · Tel: 01803 833 123
E: sales@dartmouthsmokehouse.co.uk · www.dartmouthsmokehouse.co.uk

The Dartmouth Smokehouse is a family affair, chaired by Andrew Obolensky with sons Nick and Edward as managing director and director of finance. Andrew Obolensky was previously with English Provender and founded his new company on the site of old crab-processing sheds some thirty years ago. In 1975, Devon Oak, as it was then known, went into the business of smoking mackerel. With the arrival of the Russian trawlers, the balance of fish stocks altered radically and by 1985 it was deemed a good idea that chicken and duck join the list of foods smoked. Recently the business has merged with Cornish Smoked Fish to become West Country Smokehouses, the combined equipment now dedicated to creating a major smokehouse for Devon and Cornwall. However, trading continues locally as the Dartmouth Smokehouse.

After climbing the long hill out of Dartmouth towards the Naval College, it felt like a just reward to arrive at the Smokehouse simultaneously with a new line of smoked cherry tomatoes being dished out for tasting in the office. Verdict: delicious. The range of smoked foods is infinite, from mussels and oyster, garlic, quail, cod's roe and kippers to goose breast, beef, bacon, chicken and venison, to name but a few.

Nick Obolensky's job is to source the produce. It must be fine quality, but also of uniform freshness and preferably uniform size to get an even smoke. Wild salmon and mackerel come from Scotland, farmed salmon from low-density pens in Norway, cod's roe from black cod caught in the English Channel, brown trout and chicken from Devon – and the 'sunsalt', the sea salt used in the curing, from Israel. The wood for smoking includes a blend of oak, beech and chestnut, the beech adding a touch of sweetness; apple wood is used for bacon. Hot kiln-roasted salmon is one of Dartmouth's core products; the fish is marinated in sea salt, sugar, dill, honey and black pepper and in the traditional way used by the Red Indian tribes, it's kiln-roasted over hickory and oak chips. Hickory trees are part of the walnut family and come mostly from South America.

The secrets of smoking and the smokehouse are held by John Sharam, an eighty-hour-a-week man whose surname is that of one of the three big families in the town. The process begins daily at 5.00am and 'must be the right smoke for the job', as was pointed out by Philip Watts, another partner in the business and a man with a contagious enthusiasm for good food: 'you want nice big cumulus clouds of smoke for salmon.'

The Dartmouth Smokehouse has many prestigious customers including The New Angel in Dartmouth, The Horn of Plenty in Tavistock and The Ivy in London. They also have a project afoot to introduce outdoor traditional pit smoking and to build a new shop. At present the smokery is open from Monday to Friday, 9.00am-5.00pm, and if you have any specific orders, it's advisable to telephone in advance. There are lots of outlets for the produce; the nearest is the Smith Street Deli in the Old Shambles, Dartmouth and at Darts Farm Shop outside Topsham.

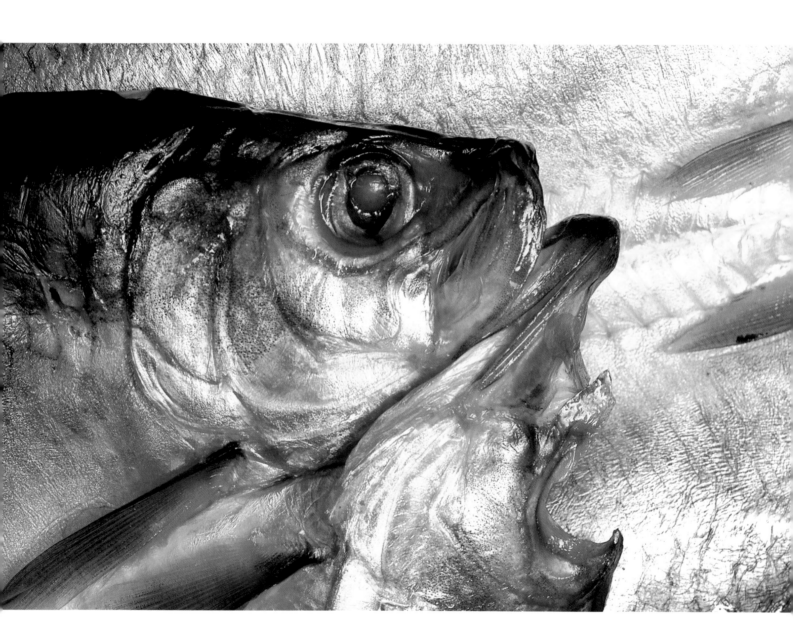

SHELLFISH BISQUE

Serves 4

Strictly speaking, a bisque is quite a thick soup, usually fish-based and with the addition of cream. Fresh crab is, for me, far superior to lobster. After I've eaten the sweet meat, it's a bonus that shells and heads (minus the dead men's fingers) can be crushed and frozen until the time is ripe to make stock or bisque. Sometimes I use the resulting soup as a base for poaching chunks of fish and making a hearty meal, sometimes as straightforward bisque. A handful of prawn shells or a few mussels thrown into the stockpot never go amiss. Using rice in the final stages makes the soup thicker and naturally creamy.

50g butter (1³/₄oz) butter
1 large onion, peeled and chopped
750g (1lb 10oz) bashed up crab shells, heads and legs
2 carrots, peeled and chopped
2 leeks, trimmed and chopped
1 bay leaf
3 tomatoes, chopped
1 tbsp tomato purée
1¹/₂ litres (2³/₄ pts) stock – fish, vegetable or chicken
2 tbsp rice
Salt, pepper and lemon juice for seasoning

1 Heat the butter in a frying pan and soften the onion, add the shells followed by the brandy and turn up the heat for a couple of minutes. Turn into a large saucepan and add the carrots, leeks, bay leaf, tomatoes, tomato purée and stock. Slowly bring to boiling point and simmer for 45 minutes. Strain through a colander into a big bowl – discard the shells.

2 Pour back into a clean saucepan and stir in the rice. Bring to the boil and simmer for 20 minutes to reduce the stock and cook the rice. Strain through a sieve and rub through some of the rice until the stock has thickened. Check the seasoning and serve either as bisque with a little cream, or as a rich stock in which to poach scallops, prawns, pieces of monkfish or fillets of red mullet.

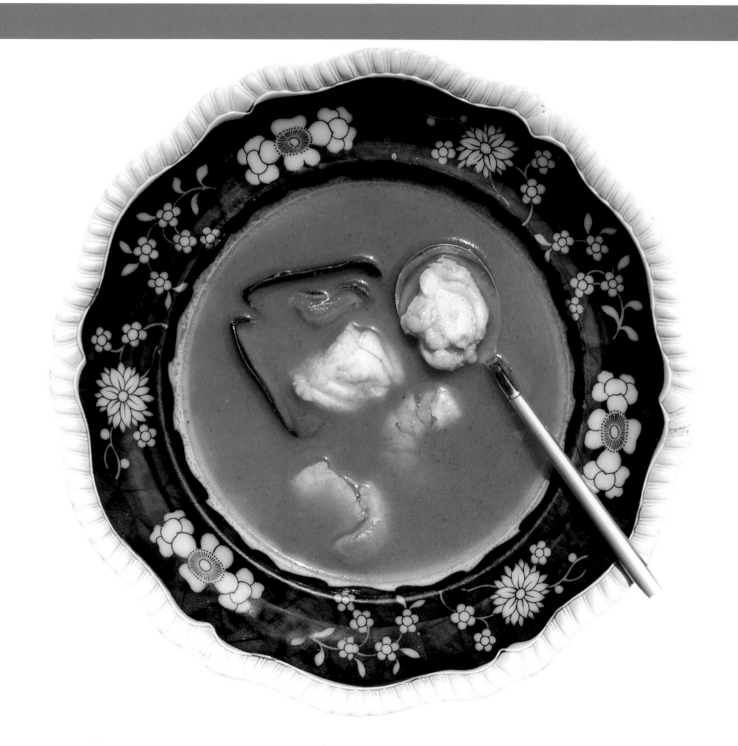

BROAD HORIZONS FISHING COMPANY

Mark Cawsey and Chris Wills · 126 Stoop · Higher Clovelly · Bideford · Devon · EX39 5RW
Tel: 01237 431198 / 07855 099717 (Mark Cawsey) · 01237 431139 / 07779 037857 (Chris Wills) · E: bhfcfish@aol.com

Logs are stacked meticulously under the lee of Mark Cawsey's slate-roofed cottage in Higher Clovelly, set away from the hubbub of one of Devon's most famed villages. Mark's a true Devonian, returning to his roots after a career in London and training as a helicopter pilot. That role was never realised as a spell of ill health sent him scurrying back to the West Country in search of new horizons. He became a lifeboatman at the Clovelly station, where he met his wife Dee at the lifeboat house and went into business with fellow lifeboatman and his new brother-in-law, Chris Wills. They bought their first boat, *Maid of Orleans*, in 2001.

Their business logo reads 'From our Trawler to Your Table'. They are fishermen rather than fishmongers and their objective is simple. No-frills fish, as fresh as you can get – just as the logo promises – and with no middlemen, it's a good deal for all concerned. Now working from a newer and slightly bigger vessel *Helcon*, the budget is based on the boat being at sea for a hundred and fifty days a year, more if the weather allows, but the unpredictable – such as the time someone tried to steal the boat and she was out of the water for nine weeks – takes a toll on finances.

Division of labour is straightforward. Mark is shore-based, allowing Chris to fulfil his passion for the sea where he fishes with the help of a crew, usually for a maximum of thirty-six hours at any one stretch. The boat can operate up to a force five, then it becomes uncomfortable for the crew and difficult to keep the net fishing efficiently. As soon as radio contact is made and there's a guesstimate on the catch, Mark rings around his contacts, including a number of commercial kitchens, to see what they will buy. 'It's a bit of a lottery, first come, first served, but the phoning is rotated so at some stage everyone has the prize pickings of the day's catch.'

Helcon, classified as an under-ten-metre trawler, has a mooring at Clovelly, but is more often to be found at Appledore where there are facilities for refuelling and taking ice into the hold for packing the fish at sea. Fuel costs, incidentally, have rocketed by 95% in the last few years. The further advantage of Appledore is that once Mark has sorted the customers' orders, the rest can go straight to the wholesaler, and odds and sods like spider crab and dog fish, to the bait man. Mark and Chris aim to keep deliveries within a six-mile radius, but do travel further if orders are sufficient.

Shellfish are not their target, although a handsome lobster was amongst the catch on the dreary morning we photographed *Helcon* – the shipping forecast had hurried her return to the quay twelve hours early. The catch is seasonal, red mullet, squid and John Dory amongst the summer catch; haddock, cod and their all-the-year-round staple, skate, in the winter.

Find Mark with a wide selection of the previous day's catch at Crediton Farmers' Market on the first Saturday of the month, or Okehampton Farmers' Market on the third Saturday – assuming the weather's behaved itself and the boat has gone to sea.

BLISSFUL BUFFALO

Mike Greenaway · Belland Farm · Tetcott · Holsworthy · Devon · EX22 6RG
Tel/Fax: 01409 271406 E: blissful.buffalo@belland.fsnet.co.uk

Belland Farm has been in the family for forty years, and the small Wellington boots abandoned at the door confirm there's another generation on the way. A collie with one brown and one blue eye gazes at the buffalo in the yard. Forty years ago, in 1965, Mike Greenaway's father had a handful of milking cows and bullocks that rough-grazed the land; they grew hay and 20-30 acres of cereals. Today the cereals have been dropped in favour of hay and silage for winter-feeding.

A decade ago things began to get tight, mostly thanks to the drop in value of the milk quota, and Mike felt that, whilst continuing milk production, in order to survive they must diversify and somehow cut out the middleman. He came up with the idea of buffalo milk, 'not subject to the milk quota as long as you can sell the product'. The buffalo can be milked in the same cubicles and using the same equipment as cows.

Today the farm accommodates 210 cows, 55 buffalo and about 200 other animals – the cows' milk is whisked off to the Tor Valley cheese maker, but the buffalo milk is made into mozzarella and feta cheese by Mike and his father, Horace in their dairy on another farm nearby. They sell on some of their young Romanian buffalo stock to farmers throughout the country.

Initially the Greenaways made buffalo ice cream that sold well but wasn't a big financial advantage over cows' milk – the same number of gallons sold for a similar price to dairy ice cream. 'This is despite the fact that it has a third more protein, twice the butterfat, twice the calcium and half the cholesterol – everyone should be drinking it,' says Mike.

Mike Greenaway had always had mozzarella in mind, since the initial visit to Italy that inspired the whole project. He recognized the business potential and that it was something he wanted to do, but despite having no problem talking to Italian farmers and seeing their buffalo, nobody would show him how to make the cheese. It was Vera Tooke, a one-time cheese maker on their own farm and herself of Dutch origin, who put the Greenaways in touch with a Dutchman who made mozzarella, so the family set out for Holland to learn the basic skills.

Horace and Mike Greenaway make a fine double act. As we arrived at the dairy, Horace had reached the point of stretching the mozzarella into long skeins. Mozzarella begins like cows' milk cheese, with a starter to increase acidity and vegetarian rennet to set it into junket; the curds are cut with a knife and fall to the bottom of the vat, whey goes to the pigs. Latterly the cheese is plunged into very hot water to keep it pliable for the stretching, producing the strata you see when cutting into a finished cheese. The whole process takes five hours and the cheese will be ready for eating by the evening – much of it will be sold by the following morning.

Approximately 300 litres of buffalo milk will make 390 mozzarella balls. It's vacuum-packed in salt brine and will keep in the fridge for up to three weeks.

I asked Mike Greenaway if he was a true Devonian. 'Oh yes,' he said, 'unless I'm selling to a Cornishman, and then

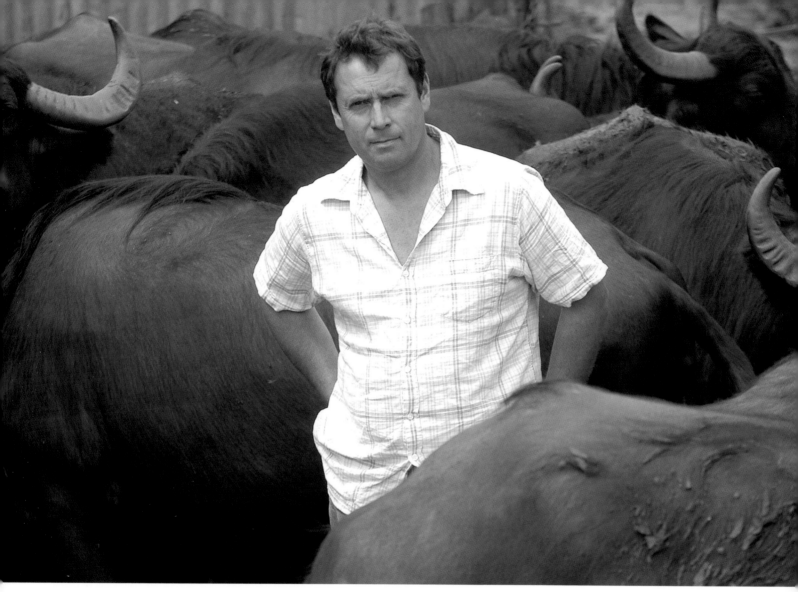

I'm Cornish.' The Blissful Buffalo mozzarellas are widely available and are the only handmade mozzarellas in the country. You can also buy their mozzarella and Feta cheese from Crediton, Cullompton, Totnes, Tavistock, Ivybridge, Okehampton and Exmouth Farmers' Markets (page 101).

It's available in the Ticklemore Cheese Shop in Totnes and in Tavistock and Topsham Country Cheeses. Buffalo meat is also available direct from the Farmers' Markets, but not wholesale.

RIVERFORD FARM DAIRIES

Robert Meadows · Riverford · Staverton · Totnes · Devon · TQ9 6AF · Tel: 01803 762131 · E: riverford.dairy@virgin.net

A Devon scone would be the duller without its traditional clotted cream and jam, so the first question for Robert Meadows, a man who makes irresistible clotted cream, was to solve the time-honoured question, 'which goes first?'. His reply, 'jam first and cream on top, but then I'm not a Devonian. I come from Peterborough where we don't even see cows, let alone clotted cream.' So the question remains open for debate.

Robert has been running the dairy since 1999: in 2002, 2004 and 2006 he won a first prize at the Devon County Show. He trained in Food Science at Seale-Hayne Agricultural College near Newton Abbot and then joined Unigate Dairies for six years – where there was a traditional scalder for making the clotted cream. Modern techniques using ovens or the microwave give a more uniform product, equally a more uniform blandness. What's more, as the product is often cooked in its final packaging, it's robbed of the delectable crusty top into which any self-respecting cream lover wants to plunge a spoon. Riverford's rugged dollops of cream and crust are hand-ladled into their cartons.

The dairy is part of the enterprising Riverford Farm, although it's independently run. In the 1950s the farm was owned by John Watson, now taken over by his son Oliver and daughter Louise. Brother Ben Watson owns the farm shop and another brother, Guy, runs a vegetable box scheme, growing much of his organic produce on site. Oliver Watson's mixed dairy herd, including Brown Swiss, Normande and Montebeliarde, graze on organic land around the farm.

The milk yield is divided roughly into 40% wholemilk, 50% semi-skimmed and 10% skimmed, the latter two items yielding their cream for clotted and double cream. The cream is then pasteurised by heating it up to 63°C for half an hour; some is retained to be sold as double cream and the remainder is transferred to trays for scalding, a process that takes about forty minutes but varies according to the time of year. When Robert is satisfied the cream has reached the right consistency, chilling begins with cold water under the trays, followed by blast-chilling to bring the temperature down sufficiently for the cream to be refrigerated overnight – and to properly set.

Clotted cream falls between double cream and butter in terms of fat content. The cows stay in for the winter, feeding on silage, and this in turn leads to a firmer cream so Robert lowers the fat content in winter to get the right consistency. In spring when the herd move to the meadows, the excessive moisture in the grass changes the chain of fatty acids in the milk and for the first week or two, the cream is much thinner and gauging scalding times more difficult. May and June, with rich pasture and plenty of moisture and sunlight, produce the best milk and cream. The yoghurt and milk from Riverford are also top of the range: as Robert explained, fresh milk has a natural sweetness but the harmless bacteria that occur in milk use up the sugar so with time the milk becomes bland. The best flavours are from the freshest milk and cream.

Riverford Dairies sell on a wholesale basis including to

door-to-door milkmen, mainly between Exeter and Plymouth. The Riverford Farm Shop, a haven of homemade bread, cheeses, vegetables, meats and much else, is well signposted on the Totnes to Buckfastleigh road near Staverton and sells Riverford Dairies' milk, cream, yoghurt and clotted cream, tel: 01803 762523. Other outlets include Greenlife, 11-13 Fore Street, Totnes, tel: 01803 866738.

Makes 8

Warm, light-textured scones for tea are an essential part
of Devon hospitality, and a very good reason to have
spoonfuls of clotted cream and strawberry jam.

> 250g (9oz) plain flour
>
> $^1/_4$ tsp salt
>
> 1 level tsp bicarbonate of soda
>
> 2 level tsp cream of tartar (baking powder)
>
> 1 level tbsp caster sugar
>
> 50g ($1^3/_4$oz butter)
>
> 1 egg
>
> 3 tbsp buttermilk

Preheat oven to 220°C (425°F) gas mark 7

1 Sift the first four ingredients into a mixing bowl, rub in the
butter with your fingertips or use a food processor to do the
job for you. Whisk the egg and buttermilk together and,
using a round-ended knife, fold it into the buttery flour until
the dough is cohesive but light.

2 Roll the dough on a floured board to about 2 cm (3/4 inch)
thick. Cut into circles, sprinkle the tops with a little flour
and bake on a floured baking tray for 10-12 minutes, until
the tops are golden.

Clotted cream and jam essential.

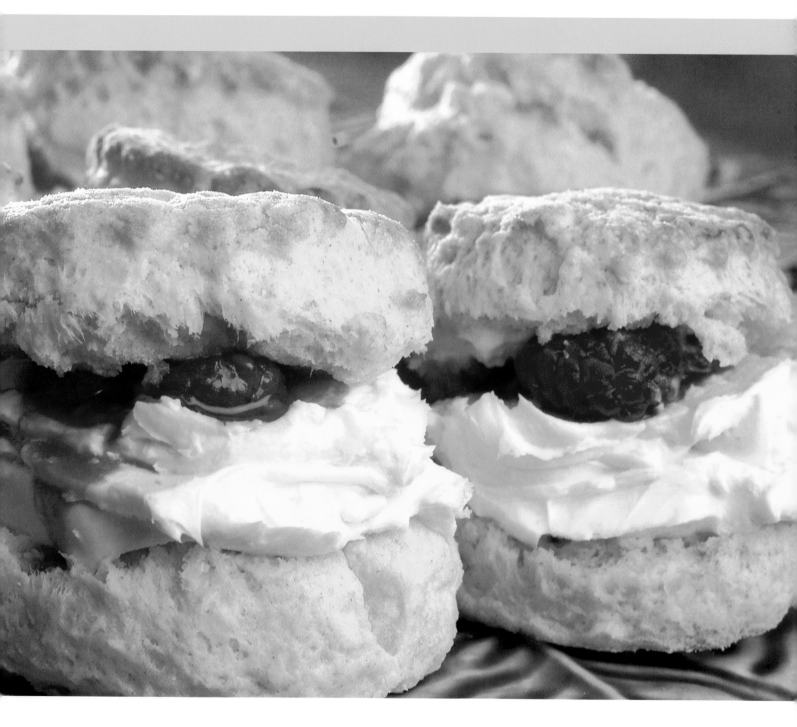

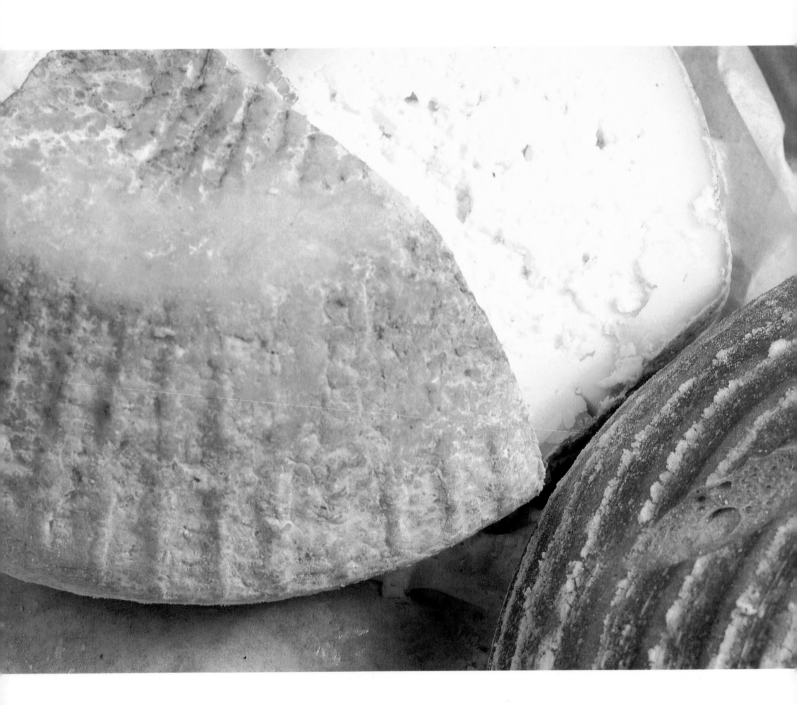

TICKLEMORE CHEESE

Sarie Cooper and Robin Congdon · 1 Ticklemore Street · Totnes · Devon · TQ9 5EJ
Tel: 01803 865926

The Ticklemore Cheese Shop is just off the main street in the centre of Totnes, selling cheeses of its own making and some from other West Country cheese makers. Ticklemore's dairy is in high Devon country with a bird's eye view of the river Dart, but like many cheese-making enterprises, various edicts mean it's not open to the public. The business was started some twenty-five years ago when Robin Congdon transferred his allegiance from farming to cheeses. His partner Sarie runs the shop whilst Robin remains based in the dairy, although he mutters darkly about bowing out and handing over the bulk of the cheese making to an enthusiastic Nick Trant, baker and chef in a previous life and now well briefed in the Ticklemore line of business.

Ticklemore produces cow, ewe and goat milk cheeses. Standing in the dairy and watching the transformation from milk to something resembling a cheese never fails to surprise, the alchemy is so speedy. Add a lactic starter to a vat of milk standing at 34ºC and within half an hour the acidity of the milk is up. Add (vegetarian) rennet and it turns to junket, ready to be cut with a knife – and cut again into thumbnail-size pieces. As the curds begin to shrink they are stirred by hand until finally the time comes to 'pitch off the whey', in other words to drain the liquid. The latter goes for pig feed and the curds are placed in moulds like cake tins with holes for drainage. They are turned a few times and depending on the type of cheese, rubbed with salt and put back into the moulds prior to moving to the cool room. Two days later the cheeses are salted again, but stay out of their moulds for another forty-eight hours at which point those designated to be blue cheeses are spiked with an ingenious homemade artefact not unlike an inverted bed-of-nails, hydraulically driven. The spiking enables the blue mould to spread evenly.

The blue mould used by Ticklemore comes from a selection produced in France; it arrives about six times a year in liquid form and is introduced into the cheese at the same time as the lactic starter.

Ticklemore's range includes ewes' milk Beenleigh Blue, a cheese that matures for six months and whose great appeal is its rich, satisfying flavour and individual character. Harbourne, the blue goats' cheese, also has an enthusiastic following for its delicious piquancy, as does the lightly salted, creamy cows' milk Devon Blue that sends one running for crusty bread and a tankard of beer. The Ticklemore buttons are individual mature goats' milk cheeses, ideal to toast under the grill or in the oven and to eat warm with rocket or watercress and tomato salad with a lemon, herb and oil dressing and a few fresh walnuts. The availability of all the cheeses varies according to the time of year.

VULSCOMBE CHEESE

Graham and Josephine Townsend · Higher Vulscombe · Cruwys Morchard · Tiverton · Devon · EX16 8NB
Tel: 01884 252505

The high-banked lanes linking mid-Devon's curvaceous landscape dip into the valleys, cut through the occasional farmyard, and rise again from woodland to more distant hills. Higher Vulscombe has its hideout in these parts.

Graham and Josephine Townsend met at Oxford University where he was reading Mathematics, and she Medieval English. In 1982, Graham resigned a Maths lectureship and bought a small rundown farm in Devon where the family, including their three young children, embarked on a new life with assets of one goat, a wheelbarrow and £1,000. Soon, with a handful of milkers, the cheese production was launched – a move in tune with the revival of British cheeses.

As the herd grew the goats were moved eleven miles away to the upper Exe valley, and into the tender care of Samantha Dunning and her parents. Numbers have now reached about sixty milkers and followers – those not yet in milk. The Townsends buy all the milk produced by the herd. The goats are a cross between white British Saanen and the floppy-eared Anglo Nubian. The British Saanen is to the goat world what a Friesian is to cows, a good workhorse but the milk is not particularly rich; the cross supplies the necessary creaminess for cheese and yoghurt making.

Most commercial goats are milked all year round and have a lifespan of about twelve years. In Samantha's care they feast on sugar beet, haylage – dried silage – and also peahaulm – the latter is the leftover when the pea pod has been removed. It's baled rather like hay. A good milking goat will give between 250-350 gallons of milk a year. To put this in perspective, the Townsends make over 50,000 cheeses a year by hand, and as the goats produce milk twelve months per annum, the necessary dedication puts paid to holidays, although the serenely rural view from the dairy and a gentle background of classical music are some compensation.

Milk is delivered three times a week and as late as eleven at night if the weather's hot. It goes into the pasteuriser at 6°C, is raised to 72°C for 15 seconds, the legal requirement for HTST, High Temperature Short Time pasteurisation, and released from the machine into the cheese vat at 7-8°C. Rennet, used to help set milk, tends to make goat cheese rubbery so an acid curd technique is employed, whereby coagulation is achieved by slowly increasing the temperature and acidity of the milk. The addition of extra flavourings, salt, herbs, garlic and peppercorns comes right at the end of the processes and even at this stage it takes about 9ozs of curds bundled into a mould to produce a 6oz cheese. Milk is an astonishing 89% water but the whey, the liquid by-product of cheese making, is perfection for pigs and helps to produce fine quality pork.

My first encounter with Graham Townsend was at Crediton Farmers' Market where he cuts a colourful dash. The cheeses are supplied throughout the South West, and elsewhere including Harvey Nichols – and the delicious herb and garlic version is available in Sainsbury's. They can also be bought from the door, but telephone in advance.

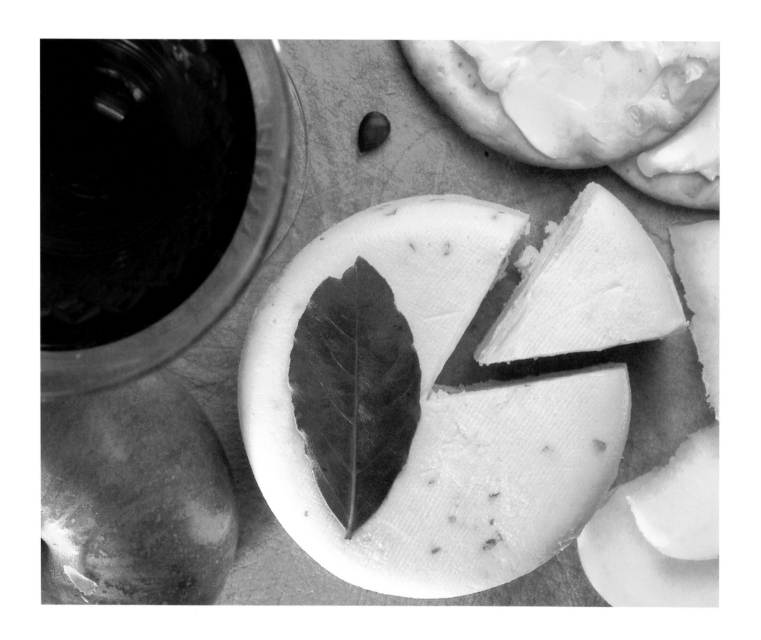

SHARPHAM VINEYARD and CHEESE DAIRY

Sharpham Estate · Ashprington · Totnes · Devon · TQ9 7UT
Tel: 01803 732203 · E: info@sharpham.com · www.sharpham.com

There's a winding road up to Sharpham Vineyard that gives ravishing glimpses of the River Dart snaking through the valley below. If I were a vine, I too would grow well on this vineyard's steep south-facing slopes that lead down to the river. Enterprising visitors can organise a boat trip from Totnes or Dartmouth and step off at the small jetty on the edge of the estate. Maurice Ash who founded Sharpham and the cheese and wine business twenty-five years ago, was a man with great foresight – he put his vines on the south side of this peninsular of land, and his cattle on the north side, hence he was able to make the marriage of cheese and wine on his own land, a fine example of farm diversification. The managing director today is Mark Sharman, a distant cousin.

Tom Hayward has been with Sharpham for five years, following viticultural experience in the Margaret River region of Western Australia. Together with Duncan Schwab, head wine maker, his job involves him in the winemaking. Peter Sudworth is the vineyard manager. Sharpham make a range of wines, from sparkling, whites and rosés, through to a variety of reds. Their sparkling wine is a blend of Kernling and Pinot Noir, and the popular Madeleine Angevine grape is the backbone for the white wines, both oaked and unoaked.

An unusual aspect of Sharpham's red wine production is that they successfully grow Pinot Noir, otherwise a notoriously difficult grape normally associated with the fine wines of burgundy and some areas of New Zealand. Sharpham's Pinot Noir won best English red wine, an award given by the UK Vineyard's Association in 2004 and 2005. They mature this wine for eight months in French oak barrels. Their everyday red is a cheerful blend of Dornfelder and Rondo, aged for four months in American oak and a little more like Beaujolais in style. The grapes for Sharpham's Beenleigh red are grown in a sister vineyard a couple of miles away using polytunnels, and are a classic blend of Cabernet Sauvignon and Merlot.

On the cheese front, all the milk comes from their organic herd of seventy Jersey cows, although the cheese is not sold as organic because of the added bureaucracy this would entail. Debbie Mumford manages the dairy and produces fifty-five tonnes of handmade cheese a year. There are three varieties: Sharpham Brie that made its debut in 1981, Elmhirst Triple Cream, in the style of a French Vignotte, and a semi-hard cheese called Rustic, natural or with chives and garlic.

Sharpham's shop and trails are open from March 1st until Christmas Eve, 10.00am-5.00pm, Monday to Saturday. They are open every day including Sundays during the months of June, July and August. There's a chance to Trek and Taste; this is a self-directed tour with an instructed tasting of wines and cheeses. Alternatively, join in The Sharpham Experience, a tour of the vineyard and a river walk to discover the wildlife of the River Dart, followed by a tutored tasting, a light lunch and a bottle of wine to take home. Advance booking is essential as tours take place only on certain days.

THE BRANSCOMBE VALE BREWERY

Great Seaside Farm · Branscombe · Seaton · Devon · EX12 3DP
Tel: 01297 680511· E: branscombebrewery@yahoo.co.uk · www.siba.co.uk

Winding lanes track from the high ground of south-east Devon into Branscombe village where thatched roofs, including that of the working forge, mark the road through its long, narrow valley. Just past the Mason's Arms at the eastern end of the village, lane and footpath converge on the bay where the crab boat sails on a good day, where the Branscombe Vale Brewery is tucked into the foreshore and where scenes reminiscent of *Whisky Galore* were played out after the January storms of 2007 – when looters made off with bounty from the abandoned cargo ship *Napoli*.

The brewery is not open for visitors, but it would be a big mistake not to stop at the Fountain Head pub at the western end of the village, or at the Mason's Arms where several of the beers are on draught, or to seek them out in pubs in Devon, Dorset or Somerset. The Branscombe Vale Brewery letterhead cites Paul Dimond as chairman and Graham Luxton as its managing director, but both directors play all the roles in the production of the beers, with up to seven on the go at any one time. Both men like a decent bitter rather than a sweeter style of beer so the house style is dry, Paul suggests almost citrussy.

Location is happenstance, but this appears a near-perfect spot. With redundancy money from a previous life, Paul and Graham pooled resources with the idea of starting a brewery, eventually stumbling upon derelict farm buildings belonging to the National Trust; the latter proving extremely supportive in the project. Setting up the brewery from scratch in 1992 meant they could create an efficient enterprise with easy maintenance; it now runs at capacity.

The critical ingredients for beer are hops, malted barley and water. The brewery has its own hard spring water, similar to the water found in the River Trent – Burton-on-Trent was once the home of great beer names. The gypsum in the water contributes to the dry character of the ultimate brew. To make the beer, the malted barley from Tuckers' Maltings in Devon is ground to grist and put into a large container called a mash tun where it's steeped in hot water and turned into a sort of porridge. During this process, the malt sugars that will later become alcohol are extracted. The liquid is run off into a huge kettle, hops are added and ninety minutes' boiling takes place. Whereas any hops will provide bitterness, to give the beer a good nose aromatic hops such as Willamette are added at the end so properties are not boiled off up the chimney. The spent hops go to orchards to be spread around fruit trees, or are used for lightening heavy soil.

The beer ferments for four or five days, the fermentation stopped by chilling to 8°C with just 5% of fermentable sugar remaining. It's then racked off into clean and sterile casks, sealed with wooden or plastic bungs, allowed to warm to 15°C which encourages the fermentation to restart and the last of the sugar to ferment out. In an ideal world the beer rests for fourteen days in barrel for conditioning prior to the pulling of the first pint. When the Queen paid her first visit to a pub in 1996 – The Bridge Inn at Topsham – she met

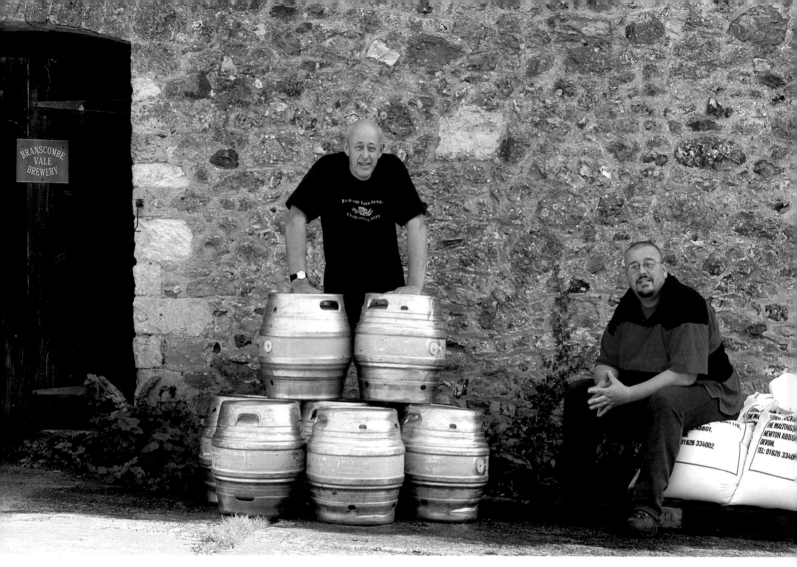

Paul Dimond and Graham Luxton. Some bottles of Branscombe beer were taken back to Buckingham Palace where, correspondence reveals, Prince Philip enjoyed them. I have to echo Prince Philip's sentiment: it's a thumping good beer.

Names include:	Branoc 3.8%, Draymans 4.2%
	Branscombe Vale Best Bitter 4.6%
Seasonal:	Summa'that 5.0%, Hells Belles 4.8%
Part timers:	Yohoho 6.0%. Anniversary Ale 4.6%

PLYMOUTH GIN

Black Friars Distillery · 60 Southside Street · Plymouth · Devon · PL1 2LQ
Tel: 01752 665292 · www.plymouthgin.com

Whiling away time in Plymouth's old streets and around the water's edge is a pleasurable business; and so is visiting Black Friars Distillery, locked into a narrow street just a stone's throw from the Barbican. The distillery is handsomely maintained; it's an inherent part of the city's history from about 1500 and its architecture suggests Dominican monks probably built it. It was at one time a brewery, Mr Coates joining an established distilling business there in 1793 and presently forming Coates & Company. From 1975 Whitbread owned the distillery and sold it to Allied Domecq in 1991. In 1996, when production was down to one still a year, four entrepreneurs put their hands in their pockets and took it over. Today Plymouth Gin makes fifty stills a year and is a player in the world market. Sean Harrison, ex-Royal Navy, trained at Plymouth Gin and is now Operations Director, alias Head Distiller, and much involved in the renaissance of the company. He describes the making of gin very succinctly: 'putting ingredients into a kettle and extracting essential oils, essential oils are really our game.'

To be proper gin, juniper must be at its heart. In the case of Plymouth Gin it's mixed together with the botanicals cardamom, coriander, lemon and orange peel and two less familiar ingredients – angelica root to add musky flavours and contribute to the overall dryness, and orris, the fragrant root of the Florentine iris, ground to a powder and, like angelica, used to add an earthiness but also to act as a glue. Orris is the agent that locks the flavour into alcohol, similarly used by the perfume industry. The aim with gin is to balance oils and flavours and to marry them. Sean says 'we do what the perfume guys do, except at the end of the day we drink it and they dab it on.'

As with whisky, the fewer impurities in the water used for making gin, the better. Sir Francis Drake had the foresight to build leats and aqueducts to bring water from Dartmoor, so Plymouth has had access to clean water for a long time. Its geography helps too; the water supply runs through peat, a natural water filter, and over granite. The distillery also has a demineralisation plant so that whatever gets put in by the water companies is then stripped out. The distillation is done in traditional copper stills.

Plymouth Gin is a variation on a classical theme. It is quality gin and the company is an exponent of The Slow Food Movement (see page 101). By using sweet orange rather than bitter, and sweet angelica, immediate flavours are picked up on the front of the tongue, giving an explosion of flavour followed by longevity of taste as it moves around the mouth. I asked Sean Harrison how he would like his G & T or his Dry Martini cocktail served. The answer to the first question was

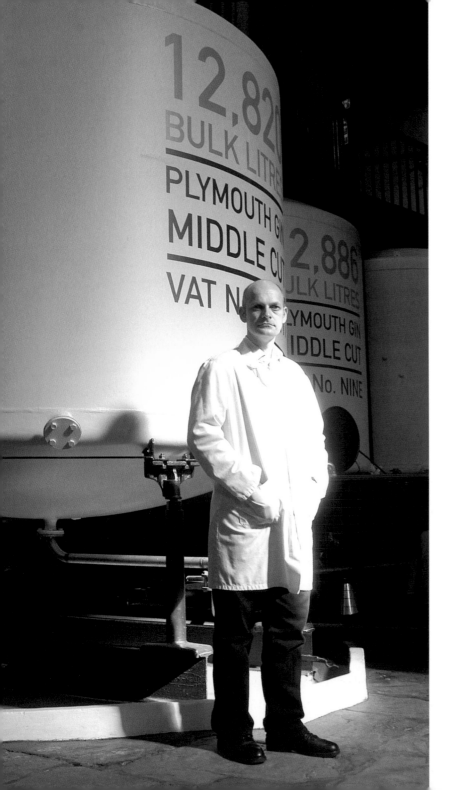

long and cold, with tonic if that's what you like, but he prefers water. To the second, he reckoned James Bond should be shot. 'Stirred, but never shaken.'

Black Friars Distillery still produces their Navy Strength 57% ABV for the traditionalists – that's quite a wallop of alcohol. Their regular Plymouth gin is 41.2 ABV. It also makes one of Britain's traditional winter drinks, sloe gin. Just as tonnes of juniper berries arrive in Plymouth each year from Macedonia and Italy, so do 20,000 kilos of sloes from Poland.

The gin is widely available in good bars and off licences, and the shop at the distillery is open Monday to Friday 9.00am-5.30pm: Saturday 10.00am-5.30pm: Sunday 11.00am-5.30pm.
Tours are available.

DOWN ST MARY VINEYARD

Bernard and Penelope Doe · The Old Mill · Down St Mary · Crediton · Devon · EX17 6EE
Tel: 01363 82300 · E: info@english-vineyard.co.uk · www.english-vineyard.co.uk

'Initially we wanted the house, not the vineyard. The move was from urban Beaconsfield where things were pretty immaculate, to a house where the front door stuck, windows wouldn't open, the garden was overgrown and the vineyard badly neglected, and we tramped in mud along with our possessions.'

Bernard Doe was on the way to semi-retirement from a job as a management consultant in London: Penelope had been with the BBC as a producer, including programmes such as 'Mastermind'. Their joint vision was to find a home, some land and a small business in rural mid-Devon. The move came in 2001, and the vineyard, not included in any of their prospective plans, became the focal point of their new enterprise.

Down St Mary is on an idyllic southwest-facing slope above the River Yeo in mid-Devon; the views are as rural as you could wish for, of grazing cattle, high fields and valleys. In 1986, six acres of white grapes had been planted. Now some have been replanted with Pinot Noir and Pinot Meunier, two of the classic champagne varieties used for sparkling wine production; something at which the British vineyards have become very successful. So much so that the sparklers win international prizes and the French are beginning to buy land in Kent and Sussex. The Does also grow Rondo and Dornfelder, so that in three to four years they will also be producing reds and rosés.

The vineyard is busy from January, when pruning begins, until the end of October. Bernard does the bulk of the work in the vineyards, described by Penelope as 'running to stay in the same place'. Pesticides and insecticides are not used, but vines are sprayed against mildew and botrytis; the weeds are kept at bay and canopy management takes place over the summer months – the trimming of shoots to allow leaf growth that produces sugar for the grapes. The training method used is the Double Guyot system, selecting two canes to grow along the wires on either side of the main stem. These canes generate the shoots that produce the grapes. A team of local people does the harvesting. At present the grapes are crushed and vinified by Steve Brookbank in Somerset, or by Vince Gower at Stanlake Park Wine Estate in Berkshire, although the Does have a big input in the blending of the wine, anxious to maintain its quintessentially English qualities.

Production runs at twelve thousand bottles a year. The wines have won medals and awards, but a particular triumph in 2005 was Bernard's label for the Yeo Valley Table wine that won best-presented still wine in the English and Welsh Wine of the Year competition.

The wines are sold at local shows, in local pubs, shops and restaurants, in Porters English Restaurant in Covent Garden and in the Does' shop which is just outside the village of Down St Mary, off the A377 Crediton to Barnstaple road and the A3072 Crediton to Okehampton road. Follow the brown tourist signs.

Shop opening times: Easter Saturday-October 31st, Tuesday-Saturday 10.30am-5.00pm; Sunday 12.30am-4.30pm; open on Bank holiday Mondays. December: Tuesday to Saturday, 10.30am-5.00pm; Sunday 12.30pm-4.30pm.

Mail order, group tours and wine tastings can be arranged.

EMMA'S BREAD

3 Church Terrace · Heavitree · Exeter · Devon · EX2 5DU
Tel: 01392 490009 · www.emmasbread.co.uk

The kitchen was in minor crisis; Emma Parkin was fists into an extra day's baking in preparation for the Exeter Food Festival, an annual spring event sponsored by Taste of the West. A large batch of carrot cake was on the run but once restrained, it baked to perfection. She moved her baking to a rented kitchen in a barn early in 2006 as the business grew.

Martyn Bragg owns the barn, The Barton at Shillingford Abbot near Exeter. He's a Soil Association certified producer and the barn is part of his family farm on which he grows ten acres of organic vegetables and runs his own vegetable box scheme. Emma likes linking with the farm, using their herbs and vegetables, wherever possible, for baking purposes, such as in the carrot cake, pasties and focaccia – dimpled Italian-style bread with herbs and sea salt. She was at one time the Press Officer for the Soil Association and helped Martyn Bragg to assemble the requisite credentials for a grant from DEFRA to convert the barn – so she has a special interest in her new working premises. The kitchens in the barn are hired out on a daily basis and neighbours further down the row include Rod and Ben – also in the vegetable box game – using one of the kitchens to make their fine soups that are to be found all over Devon.

'Food,' says Emma, 'is a bit of a family thing.' Having left Devon for a few years, she is happy to return and is interested not only in producing good bread, but is also attracted by its history, religious and cultural aspect. 'Sliced bread is an abomination,' she says. Part of her training included a short stint at the St Martin's Bakery on the Isles of Scilly. Her organic flour comes from Shipton Mill in Tetbury; her two sourdough breads need no bakers' yeast as she has developed a culture that carries sufficient natural yeast. She makes a range of seeded granary loaves and wholemeal and farm-house white bread, not to mention the Borodinsky loaf, one of the two sourdoughs. It's named after the Village Bakery in Cumbria from where she got the recipe and is a dark and exotic bread with black molasses and ground coriander.

The kitchen is functional with commercial proving and baking ovens and a mixer – other than that, everything is pummelled, rolled, filled and tended by hand. At the back door, where the smell of baking mingles with the fresh farm air, Emma's car is ready for her to load up with deliveries. This is a small business, growing fast. She is waiting for a space to become vacant in the weekly Exeter market, but meanwhile her breads are available at:

The monthly Slow Food Market in Exeter
Bon Goût, 45 Magdalen Road, Exeter. Tel: 01392 435521
Taverner's Farm Shop, Lower Brenton Farm, Kenford, Exeter. Tel: 01392 833776.

They can also be ordered with Martyn Bragg's vegetable boxes from Shillingford Organics:

Tel: 01392 832729 www.shillingfordorganics.co.uk

BURTS HAND FRIED POTATO CHIPS

The Klamp House · Belliver Way · Roborough · Devon · PL6 7BP
Tel: 01548 852220 · E: hello@burtschips.com · www.burtschips.com

According to Jonty White and colleagues, the invention of the crisp was, like many a good recipe, an accident. In the summer of 1883, the American entrepreneur Cornelius Vanderbilt sent back his French fried potatoes to the kitchen because they were too thick. The irritated chef returned them to the table, fried to a crisp – and the rest is history.

Burts produced their first batch of potato chips – known in the 1920s as crisped chips – on April Fool's Day, 1997. When I began writing *A Taste of Devon*, I had no intention of including potato crisps, but the quality, flavour and fun of this enterprise are contagious. Potatoes are locally grown: Lady Rosetta for earlies, Hermes for main and Lady Clare for late stored – even the fields are named on the packs. Parsnip chips are seasonal only, rather than importing from Spain or Portugal to cover the missing months. Flavours are produced from the best bacon I know, from Denhay Farms in West Dorset. Thereafter the story goes like this: peel, slice, give them six minutes in the fryer, rake the chips from the sunflower oil, season and bag while still warm.

DARTS FARM SHOP

Topsham · Exeter · Devon · EX3 0QH
Tel: 01392 878200 · www.dartsfarm.co.uk

The lissom girl woven in willow and poised on high outside Darts Farm Shop is to embody farming, food and the countryside: she is the icon for the land and all it provides. The shop is on the outskirts of Topsham, very near The Bridge Inn where the Queen paid her rare pub visit – a two-mile hop from junction 30 on the M5.

Some have likened Darts Farm Shop to the food halls of Harrods and Selfridges, but Darts has a finer focus. It's not just about good food, but also about local food, some from its own farmland and much from Devon and the surrounding counties. It includes such diversities as Green Valley Cyder, made on the premises in an area integral with the shop; Gerald David's meat counter knocks spots off most butcheries and the Fish Shed sells the best of local fish plus excellent fish and chips – eat there and shop after, or take them home.

There are Devon honeys and a plethora of cheeses, Burts Potato Crisps – ruinous to the figure but famed for their irresistibility throughout Devon – homemade cakes and Otter Vale pickles and chutneys. Joss Lalley, master chocolatier, works piecemeal for The Cocoa Tree, producing exotic chocolates with flavourings such as elderflower, locally picked and turned to a syrup in order to introduce the taste to the chocolate. Joss paints makes prints as a hobby, his skill apparent in some of the delightfully quirky chocolate presentations. Georgie Porgie's puddings, Orange and Cointreau, the best of Christmas puddings and others, come fresh from their kitchen in Ottery St Mary.

The Dart brothers have a maxim for the shop, 'Growing the passion'. Originally the site was all farmland and belonged to their grandparents when, in 1971, their father set up a wooden hut by the road to retail some of his own produce.

Today James and Michael Dart organize the retail side of things and Paul Dart is their man on the land. Their 500 acres of farmland include production of salads, spinach, beetroot, cabbage, cauliflower, sweetcorn – and a pick-your-own section of summer fruits. The brothers do themselves that which they know well. But they wisely bring in specialists to manage other areas of the business.

Farmers' Markets have raised the profile of local foods. Customers come to the farm shop for the same reason, with the advantage of a roof over their heads and a car park. Layout is spacious and shopping, relaxed. The building houses a restaurant and café, and should you want an Aga, the heart of a British kitchen is

represented here in the shape of an in-house Aga shop. Likewise Fired Earth Interiors and Orange Tree gifts and cards have attractive retail outlets on the premises.

Darts Farm does not offer deliveries but they are open seven days a week: Monday-Saturday 8.30am-5.30pm: Sunday 9.30am-4.30pm. See entry for the Fish Shed for their opening hours.

The following people sell at Darts Farm:

Green Valley Cyder, Fish Shed,
Suzanne's Vinegars, Gerald David Butchers,
Rod and Ben's Vegetables, Burts Crisps.

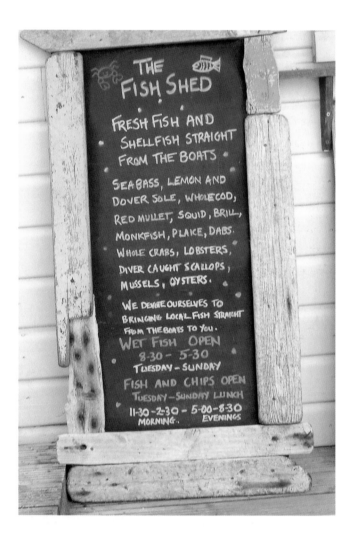

GERALD DAVID and FAMILY, BUTCHERS

Darts Farm · Tel: 01392 878203

Barry Kelland is your man at the helm behind the fine Gerald David butchery counter in the Darts Farm shop. Gerald David and Family Butchers are West Country-based, set up in 1969 and run very much as a family affair by Gerald, wife Jenny, three sons and a daughter. All the produce is farmed within a fifteen-mile radius and animal welfare considered an important aspect of their business. They own their abattoir and it is Freedom Foods Approved, ensuring animals are treated to the end of their lives with care and respect. Free-range poultry look plump and appetizing, as do the T-bone steaks, joints of lamb stuffed with apricots and herbs and pork with crackling – at the ready for the oven. Barry Kelland has been at their Topsham shop ten years. He's a cheerful man, with good reason. They have won Best Butcher's Shop in Devon, an award from *Devon Life*.

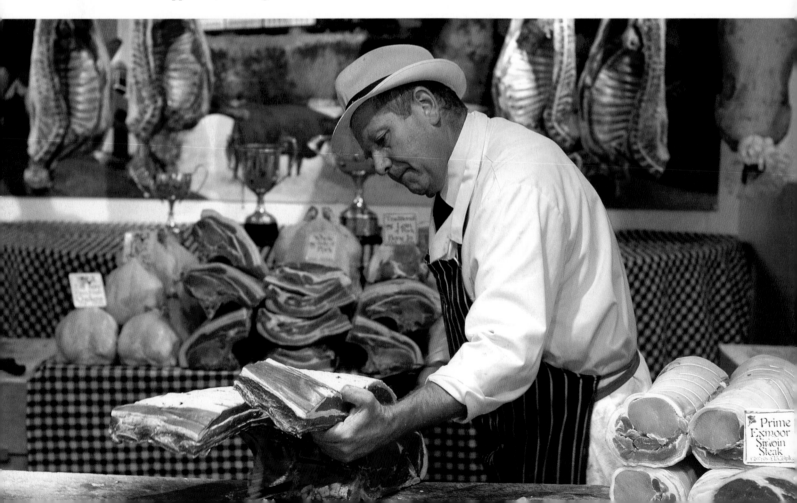

FISH SHED

David Kerley · Darts Farm · Tel: 01392 878206

The sun was out, boxes of fresh fish were being unpacked and the boss, David Kerley, was about to return to the quay to pick up fresh crabs and lobsters before nipping to Cornwall to play a key role in a projected new Jamie Oliver series. A couple wanting an early lunch strolled up to the fish shed to order. The choice is simply grilled, breaded or battered fish. David got the idea in Australia, 'with olive oil and under the grill you can't cheat – the fish must be the best.' He used to dive for his own scallops until last year when he suffered from decompression sickness – the Bends. The Fish Shed has its own premises at Darts Farm, accessible in the evenings when the Farm Shop's closed: the fresh fish is local and top quality, as are the fish and chips, with or without garlic mayo. Very occasionally, now river fishing has become so restricted, wild salmon come his way; so scarce are they that a large salmon will go under the hammer for £100. The conversation moved on to global warming, 'there were a couple of divers out at a local wreck the other day – they saw a swordfish, about 200lbs – and photographed it. You may find the odd tuna on the Irish Sea side of the coast, but a swordfish, that's almost unheard of in these waters.' Meanwhile his own counter had been stocked up with mullet and monkfish, large Dover sole, skate wings, sea bass and squid. No doubt about it, David Kerley can cook, fish and run a thoroughly professional business: he knows an impressive amount about his subject. I'll be back for more cod and chips.

Opening hours:
Tuesday-Saturday, 8.30am-5.30pm, Sunday 11.30am-2.30pm.
Fish and chips:
Tuesday-Saturday, morning 11.30am-2.30pm, evening 5.00pm-8.30pm, plus Sunday lunch.

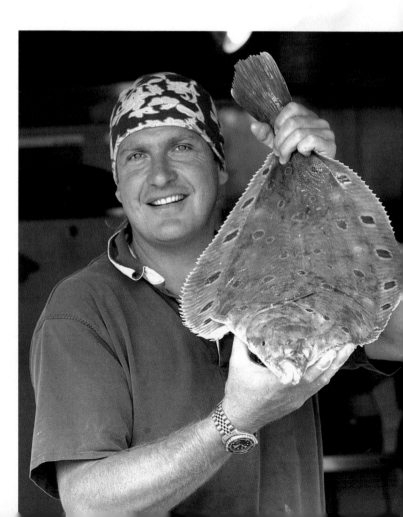

GREEN VALLEY CYDER

Chris Coles · Darts Farm · Tel: 01392 876658

The selection of wines at Darts Farm give English wines a good showing, including Sharpham and Down St Mary's wines – with separate entries in this book. The very local Pebblebed wines from Ebford have now gained organic status and their delicious rosé is recommended with Topsham mussels. The regiment of first-class local beers will tickle the fancy of real-ale enthusiasts and include Otter, Branscombe, O'Hanlans and Teignworthy. Chris Coles makes his cyder on site – through the doorway in the corner by the ales. After some years as a scientist researching respiratory enzymes in the States, Chris returned to the UK and initially joined Whiteways, the big cider company. The 'y' in the spelling of cyder is a legacy from Whiteways Cyder – rather than an attempt at being olde worlde. The cider apples come from suppliers within Devon, mixed varieties with names somehow more redolent of a country-dance than of an apple – Fair Maid of Devon, Twos and Twos, Harry Master's Jersey and Tremlett's Bitter. Green Valley sparkling Dragon Tears (dry) and St George's Temptation (sweet) are summer favourites at 4.7% vol. The prize-winning Stillwood Vintage is the speciality of the house, its fruit taken from one season, its fermentation stopped by racking to remove the yeast. The big oak vat on view holds the cider for six to eight months to mature prior to bottling: if well treated, it will keep for a further year. At 8.3% vol, it's a fine drink to enjoy with a good dinner.

Serves 4

The syllabub is an all-year pudding, but particularly special with peaches or apricots – halved and put under the grill with butter and a sprinkling of sugar and cooked until they begin to caramelize.

300mls (10 fl oz) strong cider
300mls (10 fl oz) double cream
1 tbsp runny honey
Finely grated zest of 1/2 lemon
Sprig of fresh rosemary
Freshly grated nutmeg

1 Bring the cider to simmering point in a small saucepan and continue to simmer for 5 minutes. Add the rest of the ingredients including a grating of nutmeg – stir and simmer for a further five minutes. Pour the syrup into a jug, cool and refrigerate for an hour.

2 Whip the cream and as it begins to thicken, slowly pour in the chilled cider syrup. Continue to beat until the syrup is incorporated and the syllabub will just hold the swirl of a finger.

3 Chill. Serve with baked or grilled peaches, apricots – or on its own with a scattering of toasted almond flakes.

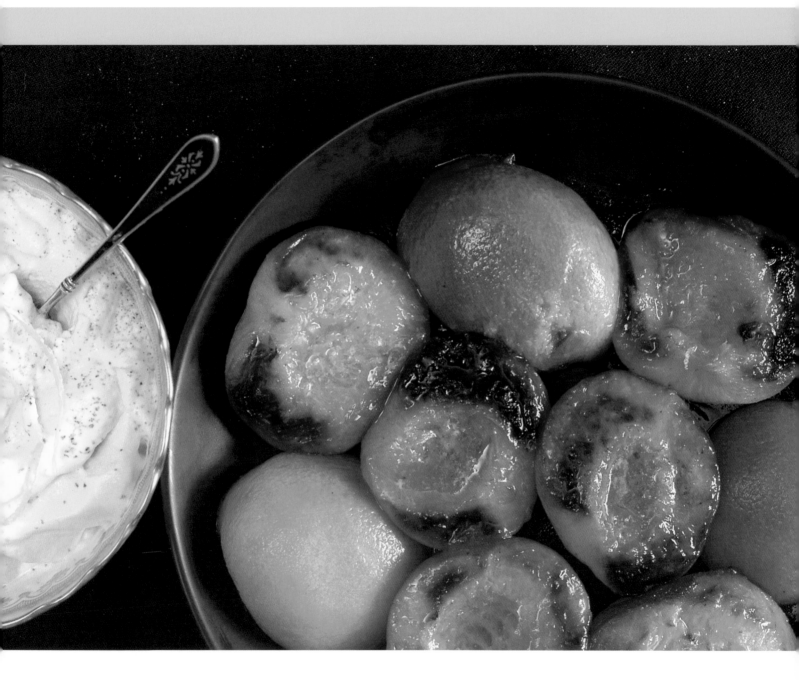

Farmers' Markets

What is a farmers' market?

The National Association of Farmers' Markets says:

> A Farmers' Market is one in which farmers, growers or producers from a defined local area are present in person to sell their own produce, direct to the public. All products sold should have been grown, reared, caught, crewed, pickled, baked, smoked or processed by the stallholder.

In other words, the pleasure of a Devon farmers' market is to buy fresh, good-quality food direct from the person who has produced it. All the food is grown or produced within a 50-mile radius of the market, so your support goes to the local community.

Further information about the Farmers' Markets and other markets can be obtained from:

Devon Rural Information, tel: 0870 608 5531

Useful web sites: www.devonfoodlinks.org.uk

www.northdevonfood.com/Producers.htm

Towns and villages that hold farmers' markets

Bideford	Ivybridge
Bovey Tracey	Kingsbridge
Bratton Flemming	Lynton
Buckfastleigh	Newton Abbot
Christow	Occombe
Combe Martin	Okehampton
Crediton	Ottery St Mary
Cullompton	Plymouth
Exeter	Seaton
Exmouth	South Molton
Hartland	Tavistock
Heanton	Tiverton
Honiton	Totnes
Ilfracombe	

Slow Food Movement

Founded by Carlo Petrini in Italy in 1986, Slow Food is an international association that promotes food and wine culture, but also defends food and agricultural biodiversity world-wide. It opposes the standardization of taste, defends the need for consumer information, protects cultural identities tied to food and gastronomic traditions, safeguards cultivation and processing techniques and protects domestic and wild animal and vegetable species. Slow Food has 83,000 members worldwide with offices in Italy, Germany, Switzerland, the US, France, Japan and Great Britain. The network of Slow Food members is organized into local groups – Condotte in Italy and Convivia elsewhere in the world – which periodically organize courses, tastings, dinners and food and wine tourism, as well as promoting international campaigns launched by the International Association at a local level. Slow Food's own publishing company, Slow Food Editore, specializes in tourism, food and wine. Slow Food international events include Salone del Gusto, the world's largest quality food and wine fair: Cheese, a biennial cheese fair held in Bra in Italy and Slowfish, an biennial exhibition held in Genoa and devoted to sustainable fishing.

For further information:

Slow Food UK

Stone House, Corve Street, Ludlow

Shropshire SY8 1DG

www.slowfood.org www.slowfoodbristol.org

The Slow Food Market

Further information on the time and place for Slow Food Markets in Devon can be obtained from Hugh Corbin, tel: 01297 442378, e: hughcorbin@yahoo.co.uk

The Soil Association

The Soil Association is the UK's leading environmental charity promoting sustainable, organic farming and championing human health. As both a not-for-profit membership charity and a certification body, the Soil Association is uniquely positioned to promote organic food and farming through the provision of crucial services to organic farmers, businesses and consumers alike, and represent organic farming at a government level. At a local level, the Soil Association's food and farming team are working to expand the organic sector by supporting organic farmers and processors and developing the supply of local organic produce to schools, hospitals, youth hostels and the hospitality sector.

Supporting the development of a thriving local food sector in Devon brings far-reaching benefits to the local economy, environment and health of local communities. Devon is the UK's number one organic county with nearly 400 farms covering over 30,000 hectares and consequently there is a vast array of delicious fresh, local seasonal organic produce available through farm shops, farmers' markets, box schemes and restaurants.

For further information:

Soil Association
Bristol House
40-56 Victoria Street
Bristol BS1 6BY
T: 0117 314 5000
E: info@soilassociation.org
www.soilassociation.org
www.whyorganic.org

The National Trust

Two products from the Killerton Estate near Exeter have recently received the National Trust's inaugural Fine Farm Awards, Killerton Cider and Killerton Honey.

Killerton
Broadclyst
Exeter
Devon Ex5 3LE
House and events: Tel: 01392 881345

The National Trust
Tel: 0870 4584000
Email: enquiries@thenationaltrust.org.uk

The RAFAEL Partnership Project

The Soil Association and Devon County Council are working together, promoting distinctive authentic produce from small and medium-sized farms and businesses who use sustainable methods to produce high quality, safe, traceable, local food for local people and local schools.

This work is part of the RAFAEL partnership project – Renaissance of Authentic Food Authenticity and Economic Links. In addition, the project offers opportunities for authentic products such as olive oil, Welsh lamb, Ruby Red beef, cheese, cider, wine, honey, olives etc to be traded between the RAFAEL regions including Devon, Wales, Northern Ireland, Côtes d'Armor in France, Andalucia, Galicia and Zamora in Spain and Tras os Montes e Alto Douro and Alentejo in Portugal.

For further information: www.rafael-eu.com

LEAF Linking Environment and Farming

LEAF is a charity set up in 1991 by a group of farmers, environmentalists, food and agricultural organisations, consumers, government and academics, who got together to do something positive for the farming industry. They were motivated by a common concern for the future of farming and were keen to develop a system of farming which was realistic and achievable for the majority of farmers. Based on work in Germany that had been carried out since 1986, LEAF was established to develop and promote Integrated Farm Management. This is common sense farming that allows farmers to manage their farms in an informed, professional and caring way. It works to the following principles:

- Commitment to good husbandry and animal welfare
- Efficient soil management and appropriate cultivation
- The use of crop rotations
- Minimum reliance on crop protection chemicals and fertilizers
- Careful choice of seed varieties
- Maintenance of landscape and rural communities
- Enhancement of wildlife habitats
- A commitment to learn team spirit based on communication, training and involvement. For example, farmers are given support such as Speak Out, a programme that trains them in getting their message – that farming matters to everyone – across to consumers, press and public.

For further information:

L.E.A.F.
The National Agricultural Centre,
Stoneleigh Park,
Warwickshire SV8 2LZ
Tel: 0247 6413 911
E: enquiries@leafuk.org www.leafuk.org

Map of the sites

number on map followed by *page number*

USEFUL ADDRESSES

Meat and Poultry

Blacklake Farm
East Hill
Ottery St Mary
Devon EX 11 1QA
T: 01404 812122
www.blacklakefarm.com

Complete Meats
100 High Street
Honiton
Devon EX14 1JW
T: 01404 47111

Complete Meats
70 South Street
Axminster
Devon EX13 5AD
T: 01297 631506
www.completemeats.co.uk

Colyton Butchers
Market Place
Colyton
Devon EX24 6JS
T: 01297 552334

Eversfield Organic
Bratton
Clovelly
Okehampton
Devon EX20 4LB
T: 01837 871400
www.eversfieldorganic.co.uk

Hayman's
6 Church Street
Sidmouth
Devon EX10 8LY
T: 01395 512877
www.haymansbutchers.co.uk

Heal Farm
Kings Nympton
Umberleigh
Devon EX37 9TB
T: 01769 574341
www.healfarm.co.uk

Higher Hacknell Farm
Burrington
Umberleigh
Devon EX37 9LX
T: 01769 560909
www.higherhacknell.co.uk

T & J Hurford
Wixon Farm
Chumleigh
Devon EX18 7DS
T: 01769 580438

Little Pirzwell Natural Meats
Little Pirzwell
Kentisbeare
Cullompton
Devon EX15 2AH
T: 01884 266250

Lloyd Maunder
Willand
Cullompton
Devon EX15 2PJ
T: 01884 820534
www.lloydmaunder.co.uk

Pipers Farm
27 Magdalen Road
Exeter EX2 4TA
T: 01392 274504
www.pipersfarm.com

Providence Farm
Crosspark Cross
Holsworthy
Devon EX22 6JW
T: 01409 254421
www.providencefarm.co.uk

Well Hung Meat
Tordean Farm
Dean Prior
Buckfastleigh
Devon TQ11 0LY
T: 0845 230 3131
www.wellhungmeat.com

Fish

The Blue Sea Food Company
19/20 Torbay Business Park
Woodview Road
Paignton
Devon TQ4 7HP
T: 01803 555777
www.devoncrab.com

Browse Seafood
4-5 Old Fish Market Buildings
The Quay
Brixham
Devon TQ25 8AW
T: 01803 882484
www.browseseafoods.co.uk

Gibson's Plaice
38 Magdalen Road
Exeter
Devon EX2 4TD
T: 01392 495344

Head Mill Trout Farm
Head Mill
Umberleigh
Devon EX37 9HA
T: 01769 580862
www.headmilltrout.co.uk

Hollies Trout Farm
Slade Lane
Sheldon
Nr Honiton
Devon EX14 4QS
T: 08452 267714
www.holliestroutfarm.co.uk

Riddlers
Sabre Close
Heathfield
Newton Abbot
Devon TQ12 6TW
T: 01626 835100

River Exe Shellfish Farms
Lyson
Kenton
Exeter
Devon EX6 8EZ
T: 01626 890133

Shellfish South West
Unit 3
Clock Tower Bus Park
Lee Mill Ind Est
Ivybridge
Devon PL21 9PE
T: 01752 895089

Fruit and vegetables
Holsworth Organics
Ceridwen
Old Rectory Lane
Pyworthy
Devon EX22 6SW
T: 01409 254450

Linscombe Farm
New Buildings
Sandford
Crediton
Devon EX17 4PS
T: 01363 84291

Riverford Farm Shop
Staverton
Near Totnes
Devon TQ9 6AF
T: 01803 762523

Riverford Goes to Town
38 The High Street
Totnes
Devon TQ9 5RY
T: 01803 863595

West Country Organics
Oak Farm
Tedburn St Mary
Exeter
Devon EX6 6AW
T: 01647 270056
www.westcountryorganics.co.uk

Organic Shops and Delicatessens
Alan's Apple
26 Fore Street
Kingsbridge
Devon TQ7 1NY
T: 01548 852308

Bon Goût
45 Magdalen Road
Exeter
Devon EX2 4TA
T: 01392 435521
www.bongoutdeli.co.uk

Effings
74 Queen Street
Exeter
Devon EX4 3RX
T: 01392 211888

Effings
50 Fore Street
Totnes
Devon TQ9 5RP
T: 01803 863435
www.effings.co.uk

The Green House
2A Lower Pannier Market
Crediton
Devon EX17 2BL
T: 01363 775580

Marshford Organic Produce
Churchill Way
Northam
Devon EX39 1NS
T: 01237 477160
www.marshford.co.uk

Mann & Son
43 Fore Street
Bovey Tracey
Devon TQ13 9AD
T: 01626 832253

Mill Street Deli
20a Mill Street
Bideford
Devon EX39 2JR
T: 01237 459282

Treloars Delicatessen
38 High Street
Crediton
Devon EX17 3JP
T: 01363 772332

Farm Shops
Darts Farm Shop
Clyst St George
Near Topsham
Devon EX3 0QH
T: 01392 878200

Kenniford Farm Shop
Clyst St Mary
Exeter
Devon EX5 1AQ
T: 01392 875938

Kenniford Farm Shop
St John's Road
Exmouth
Devon EX8 5EG
T: 01395 273004
www.kennifordfarm.com

Little Turberfield Farm Shop
Sampford Peverell
Near Tiverton
Devon EX16 7EH
T: 01803 820908

Moorlands Farm Shop
Whiddon Down
Okehampton
Devon EX20 2QL
T: 01647 231 666
www.moorlandsfarmshop.co.uk

Occombe Farm Project
Preston Down Road
Paignton
Devon TQ3 1RN
T: 01803 520022

Rod and Ben
Bickham Farm,
Exeter,
Devon EX6 7XL
T: 01392 833833

Ullacombe Farm
Haytor Road
Bovey Tracey
Devon TQ13 9LL
T: 01394 661341

Wallace's Farm Shop,
Hill Farm,
Hemyock,
Devon EX15 3UZ
T: 01823 680307

Bread
Emma's Bread
3 Church Terrace
Heavitree
Exeter
Devon EX2 5DU
T: 01392 490009
www.emmasbread.co.uk

Otterton Mill's Organic Bakery
Otterton
Near Budleigh Salterton
Devon EX9 7HG
T: 01395 568031
www.ottertonmill.com

Seeds Bakery and Health Store
35 High Street
Totnes
Devon TQ9 5NP
T: 01803 862526

Seeds Bakery and Health Store
19 High Street
Exmouth
Devon EX8 1NP
T: 01395 265741

Drink
Ashridge Cider
Barkingdon Farm
Staverton
Totnes
Devon TQ9 6AN
T: 01364 654749
www.ashridgecider.com

Bramley and Gage
4 Long Meadow
South Brent
Devon TQ10 9YT
T: 01364 73722
www.bramleyandgage.co.uk

Country Life Brewery
The Big Sheep
Abbotsham
Devon EX39 5AP
T: 01237 420808

Down St Mary Vineyard
The Old Mill
Down St Mary
Crediton
Devon EX17 6EE
T: 01363 82300
www.english-vineyard.co.uk

Lyme Bay Winery
Shute
Axminster
Devon EX13 7PW
T: 01297 551355
www.lymebaywinery.co.uk

Sharpham Vineyard and Cheese Dairy
Sharpham Estate
Ashprington
Totnes
Devon TQ9 7UT
T: 01803 732203

Cheese
Country Cheeses
Market Road
Tavistock
Devon PL19 0BW
T: 01822 615035
www.countrycheeses.co.uk

Country Cheeses
26 Fore Street
Topsham
Devon EX3 0HD
T: 01392 877746
www.countrycheeses.co.uk

Curworthy Cheese
Stockbeare Farm
Jacobstowe
Okehampton
Devon EX20 3PZ
T: 01837 810587
www.curworthycheese.co.uk

Sharpham Vineyard and Cheese Dairy
Sharpham Estate
Ashprington
Totnes
Devon TQ9 7UT
T: 01803 732203

Ticklemore Cheese
1 Ticklemore Street
Totnes
Devon TQ9 5EJ
T: 01803 865926

Preserves and Snacks
Burts Potato Chips
The Parcel Shed
Station Yard
Kingsbridge
Devon TQ7 1ES
T: 01548 852220
www.burtschips.com

Cranfield's Foods Ltd
East Down
Nr Barnstaple
Devon EX31 4LR
T: 01271 850842
www.cranfieldsfoods.com

Highfield Preserves
Highfield Vineyards
Longdrag Hill
Tiverton
Devon EX16 5NF
T: 01884 256362

Hogs Bottom Garden Delights
5 Westbridge Industrial Estate
Tavistock
Devon PL19 8DE
T: 01822 613013
www.hogsbot.co.uk

Ostlers Cider Mill
Northleigh Hill
Goodleigh
Barnstaple
Devon EX32 7NR
T: 01271 321241
www.ostlerscidermill.co.uk

Ottervale Products
Perriams Place
Budleigh Salterton
Devon EX9 6LY
T: 01395 443487

South Devon Chilli Farm
Wigford Cross
Loddiswell
Kingsbridge
Devon TQ7 4DX
T: 01548 550782
www.southdevonchillifarm.co.uk

Suzanne's Vinegars
36 East Way
Ivybridge
Devon PL21 9GE
T: 08456 120377
www.suzannesvinegars.co.uk

Tideford Organic Foods
Higher Tideford Farm
Cornworthy
Totnes
Devon TQ9 7HL
T: 01803 840555
www.tidefordorganics.com

Waterhouse Fayre
The Barn
Waterhouse Farm
Bishops Nympton
Devon EX36 3QU
T: 01769 550504
www.waterhousefayre.co.uk

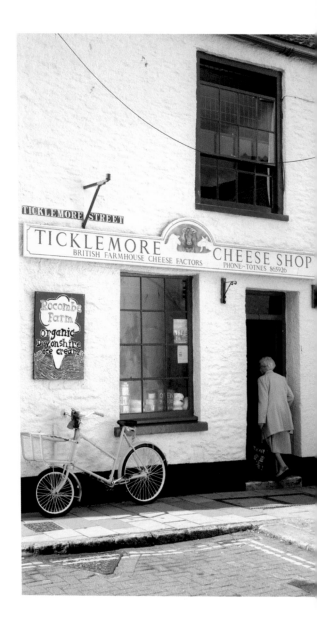

ACKNOWLEDGEMENTS

John and Angela Sansom of Redcliffe Press, whose enthusiasm turned an idea for a series into a reality. Stephen Morris, intrepid with camera, for the life and warmth of his photographs, integral to the book. Jenny and Richard Harvey who housed us when we were farthest from home, and Ed Walsh for keeping me up to scratch on rural Devon developments. Veronica Rodwell, school friend, who patiently read and sometimes reorganised punctuation. Kitchens (Catering Utensils) in Bristol, for lending us plates and dishes to use in photographs. Nicholas McClean, husband and taster-in-chief.
Clara Sansom for fine-tuning the facts and figures. The kind people we visited and who gave us much time and patient explanation.

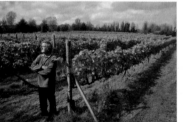

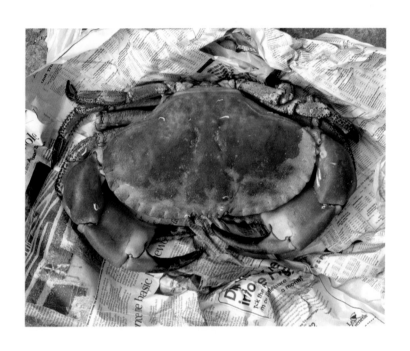